GOING FOR GOLD

CATRIONA LE MAY DOAN

GOING FOR GOLD

WITH KEN McGOOGAN

M&S

National Library of Canada Cataloguing in Publication Data

Le May Doan, Catriona
Going for gold / Catriona Le May Doan with Ken McGoogan.

ISBN 0-7710-2889-X

1. Le May Doan, Catriona. 2. Speed skaters – Canada – Biography.
I. McGoogan, Kenneth. II. Title.

GV850.L4A3 2002 796.91'4'092 C2002-903028-5

We acknowledge the financial support of the Government of Canada through the Book Publishing Industry Development Program for our publishing activities. We further acknowledge the support of the Canada Council for the Arts and the Ontario Arts Council for our publishing program.

Typeset in Berkeley Book by M&S, Toronto
Printed and bound in Canada

This book is printed on acid-free paper that is 100% ancient-forest friendly (100% post-consumer recycled).

McClelland & Stewart Ltd.
The Canadian Publishers
481 University Avenue
Toronto, Ontario
M5G 2E9
www.mcclelland.com

1 2 3 4 5 06 05 04 03 02

Even they love her, the ones who say,
When she was skating, we were racing
for 2nd place. You can see why
when she leaves the line . . .
 – Richard Harrison

Contents

I

THE START

1

❖❖❖❖❖

People ask if I have a favourite Olympic memory. I guess because I have participated in four Games, they want to know "What do you remember best?" They expect me to recall skating in one particular race, setting a record or winning a gold medal, because during the buildup to an Olympics, everybody puts so much emphasis on success. Who's going to win a medal? What colour will it be? Will it be gold? Silver? Bronze? Winning medals is something I remember, of course, because medals represent years and years and years of hard work. But I remember other moments more vividly.

With the Salt Lake City Olympics early in 2002, the first unforgettable moment happened a month before the Games and took place not in the United States but in Holland, in a little town called Wolvega, which is about ten kilometres outside Heerenveen, where we were skating in a World Cup. Ten or twelve of us, athletes with the Canadian team and a couple of partners, were sitting at a big

round table in the dining hall, eating and talking about the next day's races.

A friendly, efficient-looking woman marched through the main doors from the lobby area. She glanced around the hall and then walked briskly towards our table, carrying a telephone. The woman scanned our faces, looked directly at me, and smiled as she asked, "Catriona Le May Doan?" She handed me the phone. "You have a call from Canada."

I remember thinking, "Okay, what's this?" I wasn't expecting any calls from home. My husband, Bart, was sitting beside me. And in the past few years, with my parents and sisters, I have come to rely mostly on e-mail. So my first thought was: Has something awful happened? Is this some kind of emergency?

I stood up and took the telephone, and the call was from Sally Rehorick, the *chef de mission* of the COA, the Canadian Olympic Association. I relaxed a bit and we made small talk. I told her where I was and that we were eating dinner, and she said, "Can you talk? Maybe I should call back?"

But I said, "No, no. No problem."

I signalled to Bart that everything was okay, moved away from the table, and sat down by myself. Of course, my mind was racing: "What's this all about?" Because I had no clue. And after half a minute of chit-chat and how-are-things-going, Sally said she was calling about the Olympics in Salt Lake City, which would be starting in February. And for now, she said, this had to remain a secret, because it would be announced at a big press conference, but the committee wanted to know if, at the opening ceremonies in Salt Lake, I would carry the Canadian flag.

"Are you kidding?" I said. "How exciting!"

And later I told Brian Williams of the CBC that it had been like a marriage proposal. Because we got talking about how I had carried the flag four years before, at the Olympics in Nagano, Japan, only that was a closing ceremonies and the set-up had been completely different. All the flag-bearers from the different countries went into the arena together. You stopped in the middle and stood there and then, after a while, your team came by. It was fun to be there and see everybody walking by, taking pictures and waving, but to tell the truth, I was a bit disappointed that I didn't get to walk in with my team. So for me, Salt Lake would be a chance to change that.

Sally said, "So, are you saying yes?"

I had to laugh because in my mind, I had already said yes and had moved on to the next thought, which is typical of me. But Sally needed to hear me say yes before she felt it was confirmed that I would carry the flag. And that's what I meant by a marriage proposal, because often the word "yes" doesn't come out. People are thinking, "Well, of course," and move on to the next thought.

Sally and I said goodbye and I went back to the table. Everybody looked at me expecting me to say something, especially Bart, because we talk about everything. But I couldn't say anything because Sally had asked me to keep the news quiet until the press conference. Maybe closer to the day, she had said, I could tell some of my closest friends and teammates, but not now.

So I didn't say anything, not even to Bart, and didn't even give him a look or meet his eyes, because I knew he would guess that I was bursting with news. It was only after the dinner, when we were going up in the elevator and were finally alone, that Bart raised his eyebrows and said, "Well?"

And I said, "They want me to carry the flag."

"The Canadian flag? They want you to carry the flag at Salt Lake?"

"Yes," I said, and instantly Bart got tears in his eyes. Which is funny, when you think about it, because he's such a man's man. I mean, he comes from this old Alberta ranching family, and he's a steer wrestler and a hockey player. What people don't realize is that Bart is very proud of being Canadian. And anything to do with Canada or national pride? Whenever he watches junior hockey, the championships, Team Canada, he gets emotional. He's just very proud of Canada.

So in the elevator, when I told him about the flag, right away he got tears in his eyes. He was just so thrilled. He grabbed me and hugged me, and soon we both had tears rolling down our cheeks. Bart said, "How could you not tell me earlier? Why didn't you pull me aside?"

"You don't think that would have been a bit obvious?" I asked. "You know, I get off the telephone and say, 'Bart, come over here a minute.' Besides, Sally told me to keep it quiet. And I knew exactly how you would react."

"You knew how I would react?" Bart said. But he was dabbing at his eyes and laughing, and he knew I had done the right thing. Because when it comes to Canada, or anything involving national pride, I know Bart won't be able to hide his emotions. Not on the spur of the moment like that. Afterwards, of course, he was fine. But in the elevator, we both ended up crying. Bart claims that I started first, and that got him going, but that's not at all how I remember it. And for sure I remember that moment.

2

❖❖❖❖❖

During the buildup to the Salt Lake City Olympics, newspaper reporters kept asking me about this Canadian jinx, the so-called curse of the flag-bearer. A few athletes who carried the flag at previous opening ceremonies had failed to win medals, and so the media had this idea that it was bad luck to carry the Maple Leaf. I had considered the jinx when I had carried the flag in Nagano, at the closing ceremonies, and I had thought I would love to carry it at an opening because I was so not superstitious. I wanted to be the one to show people, look! It doesn't exist, this jinx. I wanted to prove that it's just such a hoax. The curse of the flag-bearer? Ha!

This was in my mind as I flew to Salt Lake City from Calgary, Alberta, where I live and train. Because my first race was set for five o'clock in the afternoon, I didn't fly out on the charter with most of the Canadian team. That flight was leaving late at night, and the coaches wanted me rested, so they said, "You go out in the afternoon."

Bart left Calgary before the Games began, on Monday, February 4, driving a half-ton truck piled high with gear, including my skates. He would stay with me in one of the apartments rented for the speed-skating team through the entire Olympics, and we had decided to make ourselves at home there. However, because of my racing schedule, I would stay in the Olympic Village for the first few days, then move to the apartment, then return to the village. I had packed two of everything so I wouldn't have to carry stuff back and

forth. By the time Bart left, I was pretty well organized, and it was nice to have that night and the next morning just to hang out.

On Tuesday afternoon, I took a taxi to the Calgary airport. From there, I called Bart on his cell and it was strange because he was driving into Salt Lake City. By road, it's about fourteen hours from Calgary, and I thought, Fantastic! Bart is arriving now and I'll be there in ninety minutes. The flight was almost empty: two Korean skaters, one Ukrainian skater, myself – maybe ten people in all. Very relaxing.

Our team leader met me at the airport. He's voted in by the skaters to help with capital-E Everything at an Olympics. He ferries athletes around, deals with questions from the *chef de mission*, provides the media with background, you name it. It's a difficult position, extremely busy, always with 150 people asking for something. He helped me get my accreditation right there at the airport and, because I had come in with such a small group, it took only a couple of minutes.

I collected my bags and jumped into the van. The team leader drove me to the Olympic Village, where I had to put my luggage through an X-ray machine. Then he took me to the residence and helped get me checked in. Some of the rooms assigned to the Canadian team were in a quad, with four bedrooms, two bathrooms, and a living area, and our coaches and team leader had one like that too. However, most of the rooms were doubles. You'd walk in the front door and there was a tiny area with a sink and a bathroom, and then you had two bedrooms, each with two beds.

I was to share a bedroom with one of the long-distance skaters, Kristina Groves, who was then staying in the apartments near the Oval, because she was racing right away. When I moved to the

apartments to be near the Oval myself, she would be coming to this residence. So we each had the bedroom pretty much to ourselves, which was good because they were tiny rooms. I used one bed as my dresser, and I imagine Kristina did the same.

The individual rooms had no telephones or computers, but there was a common area where you could eat snacks, watch television, or log on to the Internet. Some of the Quebec skaters were there and I hooked up with them. That was great, because you go into this Olympic Village and you have no idea where anything is, and you feel like a little kid. Suddenly you're in grade school going, "Where's the cafeteria?" Quebec skaters enjoy the fact that, even though I grew up in Saskatoon, I speak French fluently, because all through school I was in French immersion. They had been in the village for a week and took me under their wing.

Thanks to the program my coaches had designed, I had the first two days off training. This I appreciated, because you get into the village and then you remember, hey! this is different from a World Cup, where you get only other skaters around. This is an Olympics with all kinds of athletes, and everything happens at once. I got swept up meeting people and going to press conferences, yet I didn't have to worry about getting over-tired because I had those days off training. That was how my program was set up. I absolutely loved it, because I could get the business done and not have to worry about skating, and I even got a chance to see a few things.

The main attraction was the Oval, where soon I would defend my title as Olympic women's champion at 500 metres. We had skated here in December, when construction workers had been building more viewing stands. Now the place looked terrific, completely transformed – lots of colour everywhere, and flags and banners

waving, and as soon as you walked in you knew it was an Olympics. I had come to the Oval with Bart, and we looked around enjoying the transformation, but then we glanced at each other and burst out laughing, because we remembered something Bart had said when we saw this oval for the first time, in March of 2001.

I'm not telling secrets when I mention that, in winter sports, Canadian and American teams enjoy a friendly rivalry. And this extends to sports facilities like skating ovals. Since 1988, like a lot of Canadian speed skaters, I have been training at the Olympic Oval in Calgary. It's attached to the University of Calgary, so there is always lots of traffic in and out, in and out. The place has a lot of colour and life, not to mention what we like to think is the fastest ice in the world. We train there six days a week. It's our home track, and you become biased.

When we heard that Salt Lake City would be building a fabulous new skating oval, we didn't worry about the competition, exactly – at least not out loud. Builders have trouble making these structures because they're so complex, with outside supports and complicated heating and cooling systems and pipes running underneath the floor. Salt Lake had the usual difficulties, with bolts shearing off supports and part of the roof caving in, and then some piping had to be reinstalled. Finally, in March 2001, the Salt Lake Oval was set to host the World Single-Distance Championships.

The other thing you should know is that, living in Calgary, Bart and I sometimes shop at a cash-and-carry outfit called Costco, which I gather has 360 outlets in seven different countries. Costco takes a high-quality bulk approach. We're talking cavernous, barn-like buildings, cement floors, shipping pallets, steel girders overhead. Costco feels like a warehouse.

Anyway, when we arrived in Salt Lake for the single-distance championships, right away we went to the Oval. We'd heard it was very fast, maybe even as fast as Calgary, and we were full of anticipation. Six or eight of us walked in together, mostly skaters, and the builders had just finished the place, so it was literally in its bare state. We had been wondering how it would feel, because every oval has a different feel, and of course we were used to Calgary, which has so much excitement to it. And as we stood there looking around, feeling let down at the lack of colour, the emptiness, Bart said, "It's Costco with ice."

By the time we arrived for the Olympics, as I say, the Oval had been brought triumphantly to life. And even that first weekend the previous March, at the World Single-Distance Championships, several skaters broke world records, myself among them, so we knew the ice was fast – maybe even as fast as Calgary. Already, the Salt Lake Oval had become an important facility for speed skating in the United States, and that's good for our sport in general. Still, arriving for the Olympics, Bart and I had to chuckle when we remembered: "Costco with ice."

So that was a fun moment, though not a significant one. When I think of meaningful moments at the Salt Lake Olympics, I always come back to meeting Brian Maxwell, the man who walked in front of us at the opening ceremonies, carrying the sign saying "Canada" into the stadium. In preparation for those ceremonies, athletes and coaches had to gather at the basketball court on the university campus. That's where the officials would put everybody in order, all the different countries: "Okay, Canada, step right this way, please."

First, everybody had to walk from the Olympic Village to the basketball court. We walked about ten minutes, maybe halfway, but

then the parade halted. It was cold outside and everybody was wondering, "Why have we stopped?" Turned out that, in order to reach the basketball court, we had to cross a bridge over a road, and at that moment the president of the United States, George W. Bush, was approaching in a cavalcade of cars. So we stood waiting, and then we saw the president's cars going underneath the bridge. And I remember thinking, "How neat!" Because living in Canada, that's not something you see every day – the most powerful man in the world driving past.

Approaching the stadium, we could see lots of lights and hear the noise of the crowd and the ceremonies beginning, and we marched in maybe half an hour late, so we missed the very beginning, though really we didn't mind. The way it worked was that, just outside the stadium, three minutes away, we stopped to get organized. People were posing for pictures and joking around, and I was waiting for somebody to give me the Canadian flag. I was standing with Hayley Wickenheiser, who is both a great hockey player and an athlete I admire.

We're very alike, I think, in the way we approach our sports. We're not super-vocal, either of us, though we're vocal enough, but when we go into our sports we're both very determined. My husband, Bart, is a very good hockey player, and he has played alongside Hayley, because when the Canadian women's team practised against male teams, some of the men started to play too aggressively. So the women asked Bart and a couple of other men to come along, and they would go out and play. I know he's not the only one, but Bart says Hayley is the best female hockey player in the world. She has amazing technical skills, and yet when you meet her off the ice, she is so quiet and unassuming, and you wouldn't

know she is this driven person. The thing you notice on the ice, Bart says, is how determined she is, and how tough, mentally. She never stops digging, and she never, never, never gives up.

Great determination, in other words. I think Hayley and I are similar in that way, and maybe in a few others, and that's why we both identified strongly with Brian Maxwell. He walked over to introduce himself while we were standing outside the stadium, and he was carrying the official placard saying "Canada." Brian told us that he had qualified for the Olympics as a marathon runner, and that he was supposed to participate in the 1980 Summer Games – but then Canada boycotted those games. And I remembered hearing something about that from Diane Jones Konihowski who, like me, comes from Saskatoon.

Because of the boycott, Brian never got a chance to compete at an Olympics. He went on to say that he and his wife created PowerBar, and click! I remembered hearing about the man who founded the company, which is a sponsor of mine, and how he and his wife had started making these high-energy bars in their kitchen, and now PowerBar is just huge. So already I was intrigued, and I thought, "What a success story!" And then Brian said, "I didn't get to go to the Olympics in 1980, but here I am twenty-two years later, and I am just about to walk into the stadium with Team Canada. And you know what? I feel really proud."

Something about that hit me. And I could see it hit Hayley, too. Twenty-two years is a long time to wait, but at last Brian Maxwell was going to get his moment. As we walked into that stadium, Brian was not just some man walking in front of us with a sign. He was part of our team. And it was very fitting, somehow, that he was the first to enter.

So that's what I was feeling as I carried the Canadian flag into the stadium. I wasn't thinking about setting Olympic records or winning gold medals. And I have no idea what Brian Maxwell's ranking was, internationally. To me, it didn't and doesn't matter. Of course, athletes want to win medals, and the more the merrier, because they give evidence of excellence. They're the product of years and years and years of hard work. But twenty years from now, when I look back at the Salt Lake Olympics, besides the controversies, besides the emotions and the medals, I'll remember Brian Maxwell and how proud he was. I'll remember Brian Maxwell saying with his presence, Here's Canada, and this is what we're all about. And feeling so proud to be Canadian.

3

Experts will tell you that, in any game or sporting competition, mental and emotional toughness make the difference. How well do you handle pressure? That's an especially good question at an Olympic Games, where the pressure is extremely intense because you're representing your country, and naturally you want to make people proud. I denied it at the time, that I was feeling anything unusual, but looking back at the Salt Lake Games, I think the pressure was the worst I've experienced.

Part of that was because of September 11. Even though Bart and I don't get up super-early, I'll get up early enough to eat a bowl of porridge and enjoy a cup or two of coffee. That's just me. I hate rushing off to training, so my daily routine includes watching a local morning show on TV. I remember we were scheduled to have a really hard training that particular day, and I wasn't looking forward to it. I flicked on the TV and saw those smoking towers and thought, What is this? Some kind of movie? Bart had worked a night shift at the Oval, where he drives a Zamboni and takes care of the ice, so he was still sleeping.

At first, I couldn't understand what I was seeing. I kept thinking, This must be a movie, it's got to be. And suddenly you realize it's not, that it's real, and you feel just sick. I couldn't tear myself away. I kept thinking, I'm going to be late, and then, I don't care if I'm late, this is more important. I was supposed to be at the Oval to train, and I hate to be late for anything. Also, this was an important day for me and Jeremy Wotherspoon, Canada's top male skater, because on the thirteenth of September we were supposed to fly to Salt Lake City, where the world-record wall at the new Oval was to be officially opened.

The all-round skaters, those who focus on the longer distances, were already down there, staying in the apartments Team Canada had rented. They were staying a week, and then they would come home and the sprinters would go for a week to get acclimatized. Because we had set world records at the Salt Lake City Oval, Jeremy and I were heading down before the rest of our team, to attend this grand opening. I kept thinking, Well, I'll have to go . . . I'm really, really late. . . . Finally I left for the Oval, and as I left I

woke Bart and said, "You want to get up and watch the TV. There was a terrorist attack." He looked at me as if to say, "What? What are you talking about?"

Finally, scratching his head and saying "What?", Bart got up to watch. I jumped in the car, turned on the radio, and drove to the Oval, which takes ten minutes. In the dressing room, I met other skaters, and as we changed and made our way through the halls and onto the ice, all we could talk about was this terrible attack. A few skaters had gone to the Oval early, and others don't drink coffee, or don't have the routine of watching TV in the morning. So they had been skating around saying, Where is everybody? Because most of us failed to arrive on time. A lot of skaters ended up like me, thinking, I have to go, I'm going to be late, but then couldn't tear themselves away.

It didn't help that we had a brutal training that day. And already I was going through a tired period, and feeling irritated. I can tell when I'm tired, and so can Bart, because everything bothers me, I get upset over nothing. And we were just a miserable group. We got through the training, about two hours on the ice, plus warm-up and warm-down, but we were just miserable, all of us.

Then, as I said, some of us were supposed to fly to Salt Lake. But the airports were closed, or no flights, anyway, to the United States. What we were going to do? Two days later, in the morning, I thought I was still flying out. I had phoned the airport the night before, I had packed, I was ready to go. But when I phoned again, all flights to the United States were cancelled. So we went back and forth for a couple of days, because except for Jeremy and me, the team was supposed to leave on the fourteenth. Finally I suggested

to Sean Ireland, our coach, that maybe we should rent a van and drive. On the other hand, maybe we shouldn't bother going, back and forth, back and forth, until we decided it wasn't worth it. We weren't going.

In the end, we sprinters were the lucky ones, because at least we were stuck at home. The long-distance skaters were stuck in Salt Lake. Every day they kept phoning the airport and phoning the airport, and they couldn't get home. So I felt grateful that we were in Calgary. We were going to Salt Lake in December anyway, so we'd still have a chance to get the feel of place.

This little upset was nothing, I know very well, compared with the horror, the pain, and the suffering that happened that day. But everyone says you remember where you were and what you were doing when big events happen in the world, and usually they mean tragic events. This is how it was on that terrible day, and in the grim days that followed, for a group of Canadian skaters.

Although we didn't know it in those early days, the repercussions of September 11 had not yet begun. They soon made themselves felt, though. As speed skaters, we faced the problem of how to get our skates to Salt Lake City to race in December, because we found out that, with the new security measures, we could not take them onto a U.S.-bound flight. And that worried us. Everywhere we go, we bring our skates onto planes, and we don't let them out of our sight. Checking them as baggage meant the chances of their getting lost were greater. And how were we going to pack them? The blades are delicate. They can't be banged around, because they're very fragile. They bend. Some skaters have spare boots and blades, and I did have some extras, but I didn't like my spare blades, because they aren't the

same. And I was feeling that if my usual skates got lost, I might as well not skate.

What to do? People started talking about using those big, professional camera cases, which are like foam-packed suitcases, so in December I borrowed one to go to Salt Lake for the World Cup. The man who built them was giving them away as gifts to first-place skaters. So I was glad I won the World Cup in Salt Lake because I got to keep this case. Amateur athletes aren't rich, and these cases cost several hundred dollars – they're very solid, with foam inside, and I even got one with wheels. That's how I bring my skates in and out of world competitions now. I look like a figure skater, wheeling around my bag. Even so, the first time I checked my skates in at the airport and saw them rolling away down the conveyor belt in their case, I felt like crying. It must have shown on my face because Bart looked over and said, "Catriona, what's wrong?"

At the Olympics, security was the tightest I have ever seen. Police and military personnel were everywhere, 16,000 of them in all. For every athlete, there were six police. Being in a vehicle was the worst. When you were travelling from the village to the Oval, a forty-five-minute drive, you weren't allowed to get out of the van anywhere in between. And the van was monitored by satellite and GPS, or Global Positioning System. If the van went off course or stopped where it wasn't supposed to, security would be around it in a minute, wanting to know what was going on.

Outside the Oval, you had to pull over, turn off the vehicle, and sit. You couldn't get out. Security people would open all the doors, look under the hood, look in the trunk, look in the tire wells. They did an intense check, just to make sure that nobody had planted

anything in the vehicle, after which you could drive it into the facility.

With our bicycles, it was much the same. We bring our bicycles and use them to get around, and also we bring a so-called trainer. You fix that on the back wheel and suddenly you've got a stationary bike, which you can use to warm up or down. The coaches had brought all the bicycles to Salt Lake, and we kept them at the apartments, which were two minutes from the Oval. That's how we skaters got back and forth. When we biked over, they'd wheel your bike through a big machine and then tap the frame so they could hear if it was solid or not.

You would open your bag and show them, okay, these are my skates. They would feel around, and put the bag through a metal detector, so most of the time you felt very secure. But sometimes you'd think, Hmmmm, they didn't look in this corner of my bag, and what if I were carrying an explosive device? A couple of athletes said they felt really nervous, but with all the precautions, I thought that if something was going to happen, it was going to happen, and I wasn't going to worry about it. You can cross the street and get hit by a bus. That's the way I see it. For sure, security was tighter than usual, and that increased the pressure, but at least it affected everybody the same way. That's how it is at an Olympics.

4

❖❖❖❖❖

The Canadian team arrived in Salt Lake with big expectations. I never put a number on medal hopes because you can't be sure, especially not at an Olympics. We knew we had a stronger team than at Nagano, and certainly stronger than at Lillehammer four years before that, because as a country we have been focusing more on amateur sport, putting more dollars into it, and it was starting to pay off. And we have to keep moving in that direction.

It's also true that a lot of Canadians were counting the medals, led by the same people who said that Sydney was not a success. I didn't agree with that opinion, and still don't, because even though we didn't bring home all the medals we wanted, we made great progress. I don't know how many swimmers I met who said, I got a national record, or I got a PB, a personal best. You're not in the medals but you got a PB? To me, that's a success. You went as fast as you could on that particular day. Okay, other people went faster. So what?

People forget that at an Olympics, in any given event, you have only three medals. You have three medals to be distributed among thirty or forty competitors. Say there are forty. Thirty-seven outstanding athletes will not get a medal. Are they losers? I don't think so. When people say, "Oh, you lost a race," because I came second, I don't view that as losing a race. Maybe you came sixth and you didn't win a medal, but for sure you didn't lose. I have a hard time with that attitude.

And so I don't agree that Sydney was not a success. To me, Sydney *was* a success. Okay, we didn't win as many medals as some people

anticipated. As a country, we were hoping for more medals, and the same is true of Salt Lake City. We went with a great team and, sure, the potential was there. But we know that the Olympics never unfolds according to plan. It just doesn't work that way. At an Olympics, anything can happen.

Focusing on medals also gave us this crazy idea of a flag-bearer's jinx. Since 1976, five Canadian flag-bearers, all heavily favoured in their events, had finished out of the medals. By late 2001, I had heard the list more than once. Downhill racer Ken Read. Decathlete Michael Smith. Freestyle skier Jean-Luc Brassard. Figure skater Kurt Browning and speed skater Sylvie Daigle. They had all been favoured to win medals. Some of them stumbled, some got hurt. Whatever happened, they didn't make it to the podium.

In Hamar, Norway, when we announced at a splashy press conference that I was going to carry the Canadian flag, right away the question came up. Only eleven of sixteen Canadian flag-bearers had reached the podium in the past. Was that going to affect me? I was happy to be asked the question, because it gave me a chance to say that carrying the flag is one of the greatest honours an amateur athlete can enjoy. I told people there was no way this supposed jinx was going to affect me – not psychologically, not in any way at all.

Later, when the cameras were gone, I insisted again that the whole idea is ridiculous, a creation of the media. The jinx is a myth, a hoax. And I still believe that. On the other hand, all this talk of a flag-bearer's jinx didn't help. Looking back, I can see that it added pressure.

Still, arriving in Salt Lake City as part of such a strong team, I felt great. Media experts were recalling that in Nagano, we had won fifteen medals. Here in Salt Lake City, they were saying we could

win twenty or twenty-two. With this team, how could we not? In this dream world, this media fantasy, we were counting medals before we boarded the planes.

Then we awoke in the real world. The Canadian men's snowboarding team, which had recently won gold at the World Championships in Japan, got shut out of the medals. In downhill skiing, Melanie Turgeon finished eighth. Elvis Stojko, the three-time world-champion figure skater, stumbled in his short program and stood seventh in the long. In men's moguls, Stéphane Rochon had been favoured to win gold. He finished fifteenth. How could these things happen? Well, Salt Lake was an Olympics.

In the first couple of days, Canadians did receive one pleasant surprise. Long-distance speed skater Cindy Klassen raced a personal best and won a bronze in the women's 3,000 metres. We all loved that. But with exception of Cindy, the team had little to celebrate.

That's when you start thinking about the loved ones who have travelled a considerable distance to support you. You think about the folks back home who made your presence possible, and how even people you don't know are hoping and praying you do well, and about the children who are watching their first Olympics. You think about how you're representing your country. You don't want to admit it, not even to yourself, but you worry that maybe, just maybe, the team is going to let Canada down.

Next thing: Jamie Sale and David Pelletier, the Canadian figure-skating champions, were robbed of a gold medal. This followed an amazingly gutsy performance. While nearing the end of her warm-up, and just turning around after skating backwards at full speed, Jamie had got knocked to the ice. She can't weigh much more than one hundred pounds, and she was flattened in a collision with the

powerful Russian skater Anton Sikharulidze. Badly winded, Jamie was stretched out on the ice for the better part of a minute. To those watching, that minute seemed like an eternity. Somehow, she pulled herself together and, with David Pelletier, skated an absolutely flawless program. It was so perfect that at the end, David fell to his knees and kissed the ice, and then pumped his fists in the air.

The Canadian team's only competition, the Russian pair of Sikharulidze and Elena Berezhnaya, followed immediately – and they did not skate their best. The worst moment came when, at the beginning of one combination, Sikharulidze stumbled while landing a double axel. He knew what that meant, and you could see the resignation in his face. To any impartial observer, and even to one who was biased but fair, the results were a foregone conclusion.

But then, incredibly, the judges awarded the gold medal to the Russians. They gave the Canadians the silver. At this result, television commentators were astonished. Then they were outraged. That's how flagrant it was. In interviews after this shocker, and while people were still slapping their foreheads in disbelief, Jamie and David showed the world what classy people they were – and what a classy team Canada had brought to Salt Lake City.

They were upset, of course, and nothing wrong with that. They were angry about what had happened. But never once did they say anything against the Russian skaters. That's what I noticed. They realized that the skaters had done nothing wrong. During an interview, David said, "We know this is a possibility in our sport, and if we couldn't live with this possibility, we would be in another sport."

Just the way the two of them interviewed was so impressive. And I thought, Yes, this is the way Canadians conduct themselves on the international stage. And that's what I said when the media asked

me. In a tough, tough situation, Jamie and David gave a very classy performance. I think some of that came through, because first you had a morning host on a Salt Lake radio station saying, "Everybody, please, hug a Canadian." And then you had Jay Leno waving the Canadian flag on his late-night TV show. When was the last time you saw something like that? Okay, we have our rivalries and disagreements. But at Salt Lake City, when the going got tough, the average American was there.

People began calling for an investigation, and so they should have – but the Olympics were still going on. And for Canadian athletes who had yet to perform, the figure-skating scandal meant more pressure. Jamie Sale and David Pelletier had skated the gold-medal performance of their lives and had then been denied recognition. It was as if Canada could not get a break – or even a fair shake. And you want to hear something ridiculous? It was almost as if, because the flag-bearer had refused to believe in it, the Canadian jinx had gone to work against the whole team. I don't like to think about medals. But now I couldn't put them out of my mind: we were several days into the Olympics and we had yet to win a gold!

Later, for the first time in history, Olympic officials would overrule the figure-skating judges. They determined that the French and Russian judges had done a deal in the dark and, without taking away anything from the Russian skaters, awarded Jamie and David a gold medal. As events were unfolding, however, we couldn't know this would happen. And so, at some level, the team felt demoralized. We would not have said so publicly, but by this time, we had expected to be walking around with half a dozen medals. And here we had only two, neither of them gold. Secretly, some of us began to worry that we were letting the country down.

My friend Jeremy Wotherspoon, who is like a brother to me, worried about that, I believe – although he never breathed a word. During the World Cup season, again and again he had proven himself one of the fastest males in the world at 500 metres. In Hamar, Norway, just two months before, he had won the men's World Sprint Championship. Not long before that, he had set a world record in the 1,000 metres. Jeremy was only twenty-five, but at Salt Lake City, he was bent on winning a gold medal and turning things around for Canada.

I felt confident Jeremy could do it. And our teammate Mike Ireland was yet another serious medal contender. At the most recent World Championship, Jeremy had won gold in the 500 metres, and Mike had made the podium as well. All year long, together with the American Casey FitzRandolph, who also trained in Calgary, Jeremy and Mike had consistently proven to be the fastest males in the world. What could go wrong?

I did not go to watch the men's first 500-metre race. This was officially a day off for me and I was supposed to spend it relaxing. I was staying at the apartments, which were kitty-corner to the Oval and just across the street from it. Bart was going over to watch the men race and I said, "Okay, phone and keep me updated." I sat down in front of the TV, though I did have trouble concentrating on the program I was watching. When you're trying to peak for a race, rest is important. You do a few things that are very intense, very quick and fast, and then you rest. I wouldn't be racing until late in the afternoon, around 5 p.m., so I was staying up until after midnight and sleeping in as late as possible.

It was relaxing at the apartment, with just the two of us, and we had brought everything we needed to feel at home, including a lot

of videos. I would lounge around, maybe go for a walk or watch a movie. One of the other apartments housed a lot of support staff, so you could go over there and eat lunch or just sit and talk. Salt Lake felt a lot like home. A couple of friends from the Calgary Oval had sent some pre-cooked food with us, and that made life easier. Just pop a dish into the microwave and zap! You had a home-cooked meal.

I was supposed to relax, and I knew that watching the men skate, whether live or on TV, well, that would be nerve-racking. Bart talks about how he gets so nervous when I step up to the start line to race — far more nervous, he says, than when he's getting set to wrestle a steer at a rodeo. And I do understand that. I believed that both Jeremy and Mike could accomplish whatever they wanted, but I identified with them strongly enough that I didn't want to watch. I think about my mum half-covering her eyes at Nagano, and only when I'd finished racing could she sigh and say, "Ah, okay, now I can enjoy the Olympics." With Jeremy, especially, on this particular day, it was something like that for me.

Bart was at the Oval with a cell phone. And during the flood break, when the ice-makers repair the ice, he phoned to keep me updated. He told me about the Canadian men who had already skated, Patrick Bouchard and Eric Brisson, and he told me their times. And Bart said Mike Ireland was feeling quite sick — that he insisted on skating anyway, but probably would not skate his best time. And then he phoned again and said that Mike had skated and was still in contention. Then he said, "Okay, we're nearing the end: Jeremy is just about set to go." Bart promised to call me back in a few minutes, when Jeremy had finished. So I waited. Fifteen minutes

went by and no phone call. Twenty minutes, twenty-five. Thirty minutes passed and I'm thinking, Why isn't Bart phoning?

When I reach a peak in my training, I'm not at my best in other ways. Okay, let's be honest – in some ways, I'm at my worst. Bart says we're like racehorses, we skaters, because we're so ready to go, and then the tiniest little thing can set us off. So instantly, because Bart hadn't called, I was feeling frustrated: Uggh! What's wrong with that man? Why hasn't he called? So I picked up the phone, I couldn't wait any longer, and I dialled his cell phone. After a couple of rings, he said hello, and I said, "Bart! Did the men skate?"

"Yes." Bart sounded odd – not at all like himself.

"Well? Is it over?"

"Yes."

"Bart, why didn't you phone? How did Jeremy skate?"

"Jeremy fell," Bart said. "Right now, I'm sitting with his family. I'll phone you back in a couple of minutes."

With that, he hung up. For a while, it was as if I couldn't understand. Jeremy fell? How could Jeremy fall? Jeremy? Jeremy never falls! I told myself just to relax, but I started pacing back and forth, I couldn't sit still. Bart and I are very close with Jeremy's family, with his sisters and his mum and dad. Back home, we see each other all the time. Jeremy has one sister who trains in Calgary, and who lives with him, and we're really good friends with her. Obviously, the whole family had been devastated.

After a few minutes, Bart called – he had moved away from the family. He explained that Jeremy had toed in off the line. I said, "He toed in? Jeremy?" Bart explained that he had taken a couple of strides and toed in and down he went. I was shocked. If Jeremy

skates another thousand races, that will never happen again. Everybody skates differently, and the way Jeremy skates, that accident was not normal. If you watch how he fell, you see that he caught his toe, and that's why he fell forward. Still, I could hardly believe it.

I had no sooner finished talking with Bart and hung up than the phone rang. It was another close friend calling from Calgary. He asked, "What just happened?" Apparently one of the radio stations had advertised a news flash: "Coming up: Disaster for Canada at the Olympics." So I said, "Disaster for Canada? Jeremy fell." I felt quite upset, because everybody at home would be wondering what kind of disaster. Was it some terrorist attack? Maybe a bomb went off? But the disaster was Jeremy's fall.

Obviously, this was devastating – but it's not like a bomb went off. We were all still alive and well. Anyway, within five or ten minutes, everybody in Canada knew that Jeremy Wotherspoon had fallen. Both radio and television were reporting it. Then I caught something about it on the TV in Salt Lake, even though NBC didn't do a lot of live coverage.

Naturally, the Canadian team was devastated. We had felt certain that Jeremy would win our first gold medal – if not a gold, well, for sure he would reach the podium. We had forgotten that this was an Olympics. Mike Ireland had skated well, especially considering that he was sick, and he remained within reach of the podium. Still, he wasn't in the top three.

A couple of hours after the race, I ran into Jeremy at the staff condo. He was heading out with Mike and a couple of other guys to buy a submarine sandwich. I knew better than to make a big thing

out of what had happened, and that he would not want a lot of attention focused on him at that moment. I greeted them with "Hey, guys," including everybody, but I knew exactly how Jeremy felt, and he knew I knew, so I punched his shoulder just to say, "We're here, and don't let this get you down, because we're behind you."

Later that evening, Bart and I saw Jeremy again at the support staff condo, and he was back to his normal self. He watched the video of his stumble, saying, "Look at that! Would you look at that?" He was frustrated, but he realized it had happened. It happened, it's done, and you wish you could bring it back, but you can't.

At the condo, when we had finished watching the video, nobody turned to me and said, "Catriona, it's down to you." Nobody said it because nobody had to say it. It hung there in the air, unspoken. Everybody could feel it. To say the words would only increase the pressure.

Bart and I left the condo early. Later, lying in bed, of course I couldn't sleep. I tried not to think about my upcoming races and found myself remembering people and events I thought I had forgotten. How had I arrived at this moment? I wanted to think about anything but my next race! I remembered learning to skate in Saskatoon, and also the countless hours of training. I remembered moving to Calgary to train at the Oval. I remembered competing internationally for the first time, and then the first time I won a medal.

II

THE FIRST CORNER

5

❖❖❖❖❖

People talk about my determination. They write of my "dedication" and "commitment." And I appreciate that, I really do. To tell the truth, I think of myself as stubborn. I am very, very stubborn. Whatever success I have enjoyed as a skater comes partly from that. I do not give up easily. Sometimes I wonder if that characteristic comes from my Scots background.

I know, I know. Big surprise. People see my maiden name, Le May, or maybe they hear me speak French, and they think, "Aha! She's Québécoise! Or maybe French!" Fact is, I do have some French in me. My father, Iain Le May, is descended from the Huguenots. They were French-speaking Protestants who, starting late in the seventeenth century, fled religious persecution in France. Many of them, including my ancestors on my father's side, ended up in Scotland.

Both my parents grew up near Glasgow. My dad spent his boyhood in Helensburgh, which is about an hour northwest of the city.

His mother had been a McKim, a family linked with the Fraser clan. In 1963, after graduating from the University of Glasgow as a metallurgical engineer, my dad was offered a temporary teaching position at the University of Saskatchewan. By then he had married my mother, Shona Kirk – another determined Scot, I promise you. She grew up partly in Wick, in the far north of Scotland, because her mother sent her there during the Second World War, when Glasgow remained a constant target for bombs. As a young woman, she became a pharmacist.

When my parents moved to Saskatoon, they intended to remain in Canada for one year, two at most – but they have lived in this country ever since. In the early days, because they expected to return to Scotland, they gave their children – my two sisters and me – Scottish names: Fiona, Ailsa, and Catriona. A lot of Canadians find my name difficult. They pronounce it Ca-TREE-na. That's close enough, and even Bart calls me that, but really there should be an extra syllable in there: Ca-TREE-uh-na. The name is relatively common in Scotland. Catriona is the name of the boat that takes people onto Loch Ness to hunt for the Loch Ness monster. And Robert Louis Stevenson, the author of *Treasure Island*, used it as the title of one of his novels, the sequel to *Kidnapped*.

Fiona was born in 1965, Ailsa two years later. And I arrived on December 23, 1970. Our Scottish parents didn't send us to learn Highland dancing or the bagpipes, but we did attend Sunday school at St. Andrew's Presbyterian Church, and even sang in the junior choir – at least until we got too involved in sports.

Every couple of summers, when they had saved up enough money, our parents would take us to Scotland for a holiday. We

would spend time in Glasgow with my gran, my mum's mum, and visit her aunt up in Wick. Also, we would visit my dad's parents at Lochgilphead, northwest of Glasgow, and spend time in Tayvallich, a fishing village of about 200 people just west of Lochgilphead. At one point after he retired, my dad's father, an optometrist, lived in a two-bedroom A-frame there. Later, he left the place to his three sons, but my dad was the only one who used it.

Every second summer, we would spend a couple of weeks in Tayvallich. It's very near the Atlantic Ocean and I remember putting on "wellies" and playing in the water, how we'd lift up rocks and get crabs scurrying around. My mum says now that it wasn't much of a holiday for her. She would end up driving all over Scotland, because Dad was travelling to different places to consult or give papers, or else to attend the annual conference of the International Society of Metallurgists. And in Glasgow, my gran didn't have a washing machine, so with three little girls, my mum spent a lot of time washing clothes by hand.

But that wouldn't stop Mum. You kidding? One summer, she decided to visit France. Dad had work commitments to meet, but never mind. She loaded up us three girls and away she went. I was eighteen months old, so I don't remember this. But can you imagine? With three young girls, one of them a baby, you travel to France to see the sights!

When I was four years old, my dad had a sabbatical from the University of Saskatchewan. He took us to Brazil, to live for a year in Rio de Janeiro, where he taught at the university. I went to a junior kindergarten conducted in French – don't ask me why. The teacher told Mum that I could speak Portuguese, but I have forgotten most

of it. *Bom dia. Chamo-me Catriona. Sou do Canada.* Hello, my name is Catriona. I come from Canada. *Sim, sou casada.* Yes, I am married. Yes, yes! I really am married!

When we arrived back in Canada from Brazil, school had already started. I was too young, really, but because I could understand and speak French quite well, they let me into Grade 1. This was at the Saskatoon French School. A few years before, when my oldest sister, Fiona, had turned five, Mum had tried to send her to a public school. She was told no: Fiona was too young. Mum has a way of not taking no for an answer, so she sent Fiona to the only school in town that would take her – the Saskatoon French School. Fiona loved it, so we all ended up going there. And that was how Mum got interested in French. She started taking classes so she could help us with our schoolwork. By the time I reached high school, Mum had become a French teacher – and so she remains.

Later, Fiona, too, became a French teacher. And Ailsa is a bilingual geologist, though she lives and works in California. I'm the only one in the family who does not have two degrees. Mum has always said, "Yes, but you have Olympic medals." Just last summer, the University of Calgary awarded me an honorary doctorate, and Mum and Dad say that counts, too. So maybe I'm not doing too badly.

At our house, education was important. I still remember my first day of school, and going into Grade 1. My teacher was Madame Kartha. She and Mum sat me down and told me this was my seat. I remember I started crying when Mum said goodbye. And I'll never forget two kids turning around to look at me, and one saying, "Oh, there's a new girl in class! And she's crying!"

For a kid, that's a hard thing, to come in as an outsider. I always had a hard time with that, and I still do. When you walk into a

situation and you're unknown, and everyone else knows each other, that's hard. Even going to a party, later, when I was in my twenties, I never wanted to go alone – not unless I was meeting someone and I knew they were already there. I would arrive extra late to make sure.

At age five, I started taking ballet, and for six years I took lessons. That helped my balance and flexibility, but above all my strength. I developed strength in my legs by dancing ballet. "When we have kids," I tell Bart, "they're going into ballet." Fiona went into ballet before me, and she was very good. Ailsa tried it and hated it – though later she became a good speed skater, and at fifteen won a national championship.

We were all very athletic. While taking ballet, I started playing ringette, a team sport that's a lot like hockey. Take a hockey stick and cut off the blade. Instead of a puck, use a rubber ring. Still, you're on hockey skates, you're wearing knee pads, you're wearing shin guards, elbow pads, a helmet, a mask – the works. Ringette got me onto hockey skates – and I enjoyed skating. But even apart from that, I loved the sport.

Then Ailsa, three years older than me, saw a television program where skaters were barrel-jumping. Until recently, I thought she'd seen a poster, but apparently it was a TV show. The skaters talked about their sport, and Ailsa said, "Mum, I want to try speed skating."

Directly behind our house was a school. So in winter, this being Canada, that meant a skating rink, too. That's where we would skate, we three girls. I remember putting on my hockey skates and whizzing down the alley, because we always had snow, and in the alley it became hard-packed from cars driving down there, so we would skate down the back alley to the rink.

Mum kept an old pair of skates in the basement. Once or twice, she had even come skating with us. Still, coming from Scotland, where you don't get many rinks, Mum had never heard of speed skating. So to Ailsa she said, "Speed skating? What's that?"

Ailsa told her what she'd seen. Mum made a few phone calls and got hold of the Saskatoon Lions Speed Skating Club. It's a typical local club: you register and pay your fee, and then you can rent skates, and you get ice time and coaching. For the first year, Ailsa had these terrible skates. They were badly stitched, they were dull. Mum didn't know that you had to get the skates sharpened. So for the first year, people kept coming up to Mum: "You should get her better skates." After the first year, Mum said to Ailsa, "Well, if you want to stick with this and go to competitions, I guess we should get you better skates."

So then Ailsa turned to me: "Catriona, maybe these old skates will fit you?"

I tried them on and they did fit. I tested them on the back-field rink and did a lot of falling down, because I couldn't get used to the long blades. But once I had those old speed skates, naturally, I wanted to join the club. This was in the winter of 1980, when I was nine years old. At first, we did all our skating early in the morning at an indoor rink, and Mum thought, "Well, this is okay." But then, once the outdoor rinks were frozen, we began skating outdoors, and Mum would be driving us all over town in the freezing cold, wondering, "What have I got myself into?"

I skated with the club and began feeling pretty good on speed skates. Later that winter, the national speed-skating competition was held in Regina, just a three-hour drive away. Canada had lost

most of her outdoor rinks that year, because it was a strangely warm winter right across the country. Practically the only ice in the country was on Wascana Lake in Regina, so they decided to hold the championships there on the lake in front of the Parliament buildings. I remember skating out onto the ice and thinking, "How do they know it's thick enough?" When I skated out to the middle, I saw that some of the men had dug a hole, and you could see that the ice was really thick. So I relaxed.

My dad took photos at that competition. Today, they amaze me no end. There I am in my tuque and my green woollen suit, and nobody today would even dream of skating in an outfit like that, we're all so paranoid about air resistance. By this time, I was skating with the fastest girls. At an earlier indoor competition, because I was in my first year of skating, the coach automatically scheduled me to compete in the B Group. Apparently, I told Mum, "I don't want to skate in the B Group. I want to skate in the A Group." That sounds strange to me – because it's almost against my personality to do something like that. On the other hand, maybe it's not. Obviously, I wanted to compete, and to be pushed. Mum said okay, and she asked the coach, and he said, "Sure, no problem." So I skated in the A Group. And to everyone's surprise, I won the race.

Then came Regina and the national championships. I went out and skated and again, to everyone's surprise, I won gold. So I became the national champion in my age group. Then and there, I decided to keep skating.

6

❖❖❖❖❖

Mum still lives in the house where I grew up. It's on the east side of the South Saskatchewan River, a mighty waterway that runs through the heart of Saskatoon, giving it a spectacular, tree-lined valley. The house is a bungalow in a neighbourhood of bungalows, all of them built in the late sixties and early seventies. If you come across a two-storey house in the area, it's almost certainly an upgraded bungalow. Mature trees, camper vans, good schools, kids playing street hockey – the east side was a great place to grow up.

Late in the autumn, when skating season began, we would train in a rink two blocks from the house. We'd practise before school, starting at 6:30 a.m. Later in the season, when we began doing long track and needed a 400-metre oval, we would have to drive across the city to practise in the evening. Fortunately, a lot of skaters came from our neighbourhood. One family who still lives there, and who lived there when I was born, the Bruces, had a son one year older than me, and we started skating at roughly the same time. The Bruces, the Mackays – there were several families within a five-minute drive, and we kids would train together, so the parents organized a car pool.

Nowadays, Saskatoon winters seem less harsh than they used to be. Maybe it's global warming, maybe it's the mind playing tricks, I don't know. With long track, I remember, training depended on the wind chill. I never pretended to understand the math, but when the chill factor reached a certain point, we would not be able to go out. Even so, I remember skating when it was soooo cold. You'd be

layering on outfits, and you wore so many pairs of socks, your skates had to be two sizes too large. And you'd come in from skating and you'd be crying because that's how cold you were, and Mum would have to sit there and rub our toes to restore circulation.

For my parents, car-pooling was the least of the challenges – although I only appreciated that later. They worked bingos and conducted bottle drives, and at skating meets, they would help with timing and judging. Somebody had to do it. And always that Saskatchewan cold! Skaters would cross the finish line with their eyelashes stuck together. Parents would stand at the finish line with blankets draped over their arms, and they'd bring Vaseline and rub it on the faces of their kids so they wouldn't get frostbite. Sooner or later, I suppose, people will call those the good old days. But when you think about it, really, we were crazy. Just absolutely nuts!

On the other hand, I have to admit that the training paid off. Over the years, my parents have collected a few boxes full of newspaper clippings. Sorting through them, I discover that in February 1981, when I was ten, I broke two Saskatchewan records at the Alberta Open outdoor speed-skating championship in Edmonton, and won the silver medal in the Bantam Girls A category. Two years later, the same year Ailsa won the Canadian Junior Girls Championship, I became the Canadian Midget Girls champion. And the year after that, when I was fourteen, I set Canadian juvenile records at four distances – the 300, 400, 800, and 1,000 metres. As a speed skater, I was well on my way.

By this time, I had become aware of the Olympics, though apparently I focused first on provincial records. The head coach of the Saskatoon Lions Club, Brenda Webster, held most of these records. She had skated in the Winter Olympics in 1980, at Lake

Placid, New York. I don't have any memory of this, but in one clipping, I see that my skating coach, Henrietta Goplen, describes me as "a natural" and says, "Catriona is dying to get all Brenda's records, and she's doing very well at it."

So there you go. I do remember going to competitions and seeing the older skaters, who were decked out in these cool Canada suits. I remember thinking, "Gee, I'd sure like to have one of those."

Am I giving the impression that speed skating was my life? In truth, it wasn't. Spring, summer, and fall, I would get involved in all kinds of sports, but especially soccer and track. I've always said that track was my first love, even though I never joined a club – not until much later, after I left high school, when I went back to see what I'd missed. But in my early teens, I decided that a track club wasn't my style. I loved it that at track meets, I could go and compete and not belong to a club, and still win more than my share of races.

In Saskatoon, you entered high school after Grade 8. At the city and provincial championships, all the coaches would turn up to find out who would be going to what high school. And I remember Dave Elder, the gym teacher and track coach at Holy Cross High, asking me where I would be going. When I said Holy Cross, he got all excited. Teams from that school had won the Saskatoon track championship eight years in a row, and I have always felt proud that when I was in Grade 9, we won our ninth championship. And Grade 10, our tenth. Grade 11, our eleventh. Grade 12, our twelfth. Obviously, it took the whole team, but I feel proud to have been part of that tradition.

Even today, I remain close to Dave Elder and his family. They're the reason I later got involved with the spina bifida charity as a

spokesperson, because their first son had spina bifida and hydro-cephalus. What happens is that the spinal column doesn't close properly early in the pregnancy, so part of the spinal cord protrudes, and this leads to fluid pressure on the brain and skull and so to neu-rological disorders.

It's a lot of work, dealing with a handicapped child. And then when you have another child, who is able-bodied, you have two different sets of demands. Dave and Shelley were both very athletic, very active. And just the way they cope and carry on – to me, they're amazing people. I don't pretend to have done a lot, but I was able to go to a conference a couple of years ago in Vancouver, and I've appeared in some ads encouraging people to eat foods that are strong in folic acid, because that's effective in preventing spina bifida and hydrocephalus.

All through high school, Dave Elder was my coach in track. I was naturally strong in the hurdles, and also in the sprints, both the 100 and 200 metres, and I was okay in the javelin. I did some long jump, although I was never great at it, but usually I avoided the high jump. I don't like going upside down. Also, there's this bar, and when you land on it, it hurts!

Reading through those old clippings, I find Dave Elder praising my attitude and my willingness to try any event, and naming me the school's female athlete of the year: I ran sprints, I jumped, I tried the throws. I won both municipal and provincial titles in the 100 metres, the 200 metres, and the hurdles. Until 1998, at least – and who knows what has since happened? – I held the school record in the 80-metre hurdles. In my final year, when there was some tough competition from other schools, apparently I assured Dave that

"there was no way we were going to lose while [I] was at Holy Cross." He added, "She was true to her word."

Looks like I was more competitive than I remember.

Track kept me busy into the summer. Meanwhile, I worked part-time as a secretary for my dad. For years, he had taught metallurgy at the university, teaching students about extracting metals from ores, purifying and alloying metals, and creating useful objects from metals. But Dad had also done a lot of consulting, and in 1978, he had quit teaching to start his own business. I was glad to get the job. I had never worked as a babysitter, and I remember being jealous of Fiona when I was little, because she took the babysitting course and then she could babysit, which I thought was cool.

In autumn and winter, I focused on speed skating. We would compete two years in each age group, midget, bantam, and junior, and every second year I would skate against a girl from Quebec, Sylvie Cantin. She was bigger and stronger than me, and I would think, "Aw, this year I have to skate against Sylvie." She was so strong. She ended up making the national team, and we skated junior worlds together. I have pictures of me skating behind her, and I look like a shrimp. I was so skinny! All arms and legs. I had skinny legs! Honestly, I don't know how I managed. But I think I began to peak later than a lot of people. Sylvie developed early, and I remember that feeling: "Aw! This year I have to skate against Sylvie!"

When I was fifteen, I travelled to Lake Placid, in upstate New York, for a Canadian-American competition, a Can-Am. I remember going with Dad, which made it a bit special, and together we went to see the ski jump and bobsled areas. The Canadian team was staying in two houses, with guys and girls in both, and I can't imagine who organized that. I recall going into the house and being

so nervous, because most of these people were older than I was, and I felt intimidated. I'll never forget that feeling. I was quite a shy kid, really. Once I made friends, I was happy to hang out, but I found it hard to go into a new environment.

Another thing I remember, because it made me sad, was that I never received the cool "Canada suit" I was supposed to get for competing. It was the pink and grey one. It's terribly ugly, when I look at it now, but back then, I thought it was cool, and the organizers never did send me my suit. Obviously, they ran out, but I remember being devastated. That's what it's like when you're a teenager. At least, that's how it was for me.

At Lake Placid, I had some good races and placed fourth overall.

Brenda Webster, the former Olympian, had been my coach that year. She was a lot of fun, but also serious. I remember her telling me that a lot of girls quit skating around the age I was then, because they didn't feel like practising when they could be doing other things. Probably she was right. But it's funny to read some of those old clippings. Around this time, a newspaper reporter quoted Brenda: "Catriona works hard and has a good attitude. She's very competitive. I know how well she can do, but she doesn't realize her own potential. Right now, Catriona is as good as any of the 500-metre skaters in Canada. She's better at shorter distances, but her endurance will improve. She's young and she's got very good technique. The average age for the national team is twenty-one and the potential is there for her to join the national team some day."

In that same article, though I remember nothing about it, I find my teenager-self quoted: "I like school. I'll skate for sure until the end of high school. After that, it's hard to say. Some people tell me I should take a year off and just skate. But I want to go to university

and probably study engineering. I don't really want to miss a year of school."

Study engineering? That's my dad's influence.

I'm finding out all kinds of things I'd forgotten by rereading the clippings. It's impossible to keep track of these things while you're living them, but in 1985, apparently, I held North American records for my age group in the 300, 500, and 1,000 metres. The following year, when I was sixteen, I joined the Canadian up-and-comers team. It was based in Quebec, at an oval just outside Quebec City, in Ste. Foy, and I remember going to training camps there, which I really enjoyed because I got to speak French.

Meanwhile, in Calgary, they had built the Olympic Oval, providing some of the fastest ice in the world. In my Grade 12 year, I went to Calgary every few weeks to skate at the Oval. During the trials for the Olympic team, at the national championships, I came fourth in the 500 metres. The standard to make the team was 42.30, and I finished in 42.37. I remember people saying, "Are you going to reskate?" Because you could try again if you thought you could go faster. But I didn't think I could, so I didn't reskate. I didn't realize I had a chance to make the Canadian team.

Later, I learned that a lot of people wrote letters to the Olympic Association, urging them to send me as an additional, fourth skater, saying I was next in line. Although I was only seventeen, they believed this would be a good experience for me. But I didn't end up going. To be honest, I don't care now that I didn't go. I was too young. To me, high school was the most important thing. I was busy having fun. Skating was important, but I was thinking, Well, I can worry about that later. If I make the national team, I'll move to Calgary and apply myself.

In June 1988, I graduated from Holy Cross High School. That summer, the Canadian Amateur Speed Skating Association wrote me: "Great news! You've made the national team!" By then I had been accepted into general studies at the University of Calgary, where the Olympic Oval is situated. I talked it over with my parents, and we all agreed there was only one thing to do. That autumn, a few months before my eighteenth birthday, away I went to Calgary.

A winter Olympics happens every four years. You get superb athletes from around the world competing in everything from figure skating to bobsled, from moguls to downhill skiing and hockey. Between these Olympic competitions, as most people realize, different sports stage their own competitions and run their own leagues. In speed skating, every year we compete in a World Cup circuit.

The International Skating Union, the ISU, oversees figure skating and speed skating. It splits speed skating into long track, which uses a 400-metre oval, and short track, where the circuit is roughly one-quarter of that. The ISU sets a schedule, selects venues, and organizes the races. The "all-rounders," or long-distance skaters, and the sprinters, who concentrate on the 500 and 1,000 metres, usually go on separate circuits – though when the all-rounders skate

in a world championship, they also do a 500-metre race, which is where they get the name "all-rounders."

On the World Cup circuit, you compete for medals in each race. You also earn points, starting with 100 points for first place, 80 for second, and 70 for third. These points add up through the whole season of World Cup races, and the total gives you an overall World Cup ranking. In 2001–02, the circuit included ten World Cup races at 500 metres and eight at 1,000 metres. The 500s, two each weekend, were held in Calgary, Salt Lake City, Heerenveen (Holland), Oslo, and Inzell (Germany).

We recently returned to a system that gives skaters two "throw-aways," so in the 500 metres, you can throw away your two worst results. I didn't go to Oslo in 2002, because it was five days after the Olympics, so I threw away those two 500s. But I had won all the others, so it didn't matter. That decision hurt my ranking in the 1,000, however, because you could throw away only a single 1,000-metre race and in Oslo they held two.

That was the first time I decided not to go to a competition. The rest of the Canadian team flew back to Calgary before heading off to Oslo, but I drove back to Calgary with Bart, so I got home one day later than the team. And I was going to Toronto to drop the puck at a Maple Leafs game, and that was something I really wanted to do. I thought about Oslo for hours and hours, but I don't think I could have handled going. I would have gone crazy. I needed a couple of days to relax and unwind, to celebrate and come down from what had happened at the Olympics.

I think I made the right decision. Oslo was a disaster for a lot of skaters. The Oval there is outdoors, not like in Lillehammer. And the weather was terrible, so much wind. People were miserable.

They didn't want to be there. Probably because of my experience, I knew beforehand that I would not want to be skating there. Among skaters, let's face it, I have been around forever. Surely I've learned something? So even though it hurt my ranking in the 1,000, I don't regret not going. And the next weekend, when I joined the other skaters in Germany, I skated well and won races at both 500 metres and 1,000 metres.

Every year, besides the World Cup circuit, we have the World Sprint Championships – even in an Olympic year. They're held in the third weekend of January. In 2001, they were held in Hamar, Norway, and two Canadians, Jeremy Wotherspoon and I, won the male and female championships. In January 2003, they'll be held in Calgary at the Big-O – our home track.

The World Sprint Championships are different and separate from the World Cup. You skate two races on the Saturday, one each at 500 metres and 1,000 metres, and you do the same on Sunday. All four races count towards the end result. If you skate a 500 metres in 37.30 seconds, you get 37.30 "samelog points." Everything is judged according to the 500, so if you skate a 1,000 in 1:16, you halve that total (76 seconds) to get your samelog points for that race – in this example, 38. The faster you go, the lower your points. At the end of the two days, the world sprint champion is the skater with the fewest samelog points. At the ceremony, they give you a great huge wreath of green leaves that goes over your head and around your body. That's a tradition, and it makes for a lot of fun.

Finally, in speed skating there's the World Single-Distance Championships. These emerged in 1998 to replace the so-called World Cup Final. Those races were part of the season circuit, and they counted towards your overall ranking, but you couldn't miss

that Final – no throwaways are allowed. Now the Final is gone, and every World Cup race counts the same. At the World Single-Distance Championships, the name says it all. Winners become champions at a single distance, for example, the 500 metres, the 1,000 metres, the 1,500 metres, whatever. With the 500 metres, you skate two races a couple of hours apart, so you get to start in both the inner and outer lanes.

All these events attract top skaters from around the world, and it took me a while to become competitive – several years, in fact. In January 1988, having recently turned seventeen, I skated the 500 metres in a personal-best 42.27 seconds – more than five seconds off my current world record. Still, that left me only seven-one-hundredths of a second below the Olympic standard, and made me the second-ranked junior in Canada. In February, I competed in the Can-Am at Lake Placid – and it was there that I began to discover the difference between training and racing.

In those years, sprinters skated both short track and long track. When I made the national team in long track, then I began to focus. Nowadays, skaters choose one or the other from an earlier age. But young kids in different clubs around the country still use natural ice, and usually they go both short track and long track, just as we did. Technically, I wasn't as good at short track, and a lot of that is psychological. I didn't have the right personality. Short track is a bit more aggressive – though I don't mean that in a negative way. But I don't like the rule that, if somebody falls and takes me out, she is disqualified and I advance. I don't feel that the fastest person will always win. Short track also takes a lot of strategy, and that's an amazing part of the sport – but it's just not for me.

During my first season with the national team, sticking to long track, I set three provincial records, though the times are a long way off my current standards. In the 500 metres, I broke my old record of 42.27 with a time of 41.52. In the 1,000 metres and the 1,500 metres, I set marks of 1:26 and 2:15.55 respectively. In 1989, for the World Sprint Championships, I was made an alternate. On the way to Kiev, where the Junior World Championships were being held, we stopped in Heerenveen, Holland. As an alternate, I got to skate in the warm-up.

Certain Scandinavians dispute it, but most people agree that the Dutch invented speed skating. They've got racing records going back to the eighteenth century, and today, their fans are the most expert in the world. They get all worked up about the sport, and of course I love that. Heerenveen gave me my first experience of Dutch enthusiasm. To me it was crazy, skating in this great Oval with 10,000 people in the stands, half of them drunk, all of them shouting and cheering and carrying on. I was eighteen years old and my heart was still in Saskatoon (maybe it always will be). Sure, I had competed in the Can-Ams, but upstate New York is not all that different from parts of Canada, and so I count Heerenveen as my first international skating experience.

Afterwards, I skated in Kiev, at the Junior World Championships. And the following December, I jumped to World Cup competition. I remember my first race, when I felt so nervous I shook. I was shaking so badly, I thought I would get called for a false start. There's a big difference between skating Canadian championships and competing in World Cups. Experience makes a difference. You have to learn how to deal with nerves, how to deal with unfamiliar faces.

With good coaching, every year you should improve techni-
cally. The big challenge is how you race. I could always do great
training, but the transition from training to racing is a tough one. It
doesn't matter how many times you practise standing on that line
and starting. You get your skinsuit on, you get into race mode, you
move to the line, and it's different. You get more nerves. You get
the adrenaline going. As soon as you factor those conditions
into the equation, you skate differently. The biggest breakthrough
for me was learning how to race as well as I trained.

That's something I am still learning. But looking back, anybody
can see that for me, in 1992–93, something clicked. Early in the
year, in Albertville, France, I skated in my first Olympics. A couple
of weeks before the Games, the speed skaters hooked up with the
rest of the Canadian team in Annecy, a small town between Geneva
and Albertville. That was the meeting place because Canadian ath-
letes were scattered among eight villages. At Annecy, we received
maps and information on locations and protocol, and also we got
our uniforms.

Albertville is in the French Alps, and that made for a lot of travel-
ling between venues. The speed-skating team was housed at the
main village, Brides-les-Bains. It's a small resort town and I thought
it was fabulous. I didn't care how much time I spent riding around
on a bus. We travelled all over the place and took in all kinds of
events. Maybe because a lot of us were first-timers, we were not as
serious as we later became. We took time to ramble around and see
everything we could. I'm glad I did that, because later, I couldn't
allow myself that luxury. I had to remain focused.

Albertville was an eye-opener simply because it was an Olympics.
That made it different – little things like needing accreditation, or

how, on the mats that run around the track, there was no advertising. We were used to seeing advertising everywhere. And just the size and scope of the Games – so many venues, so many languages, so many athletes. You're not just with skaters, you're part of a huge team. And then the opening ceremonies, all the excitement, so much going on. I remember being in awe.

Albertville was the last Olympics where people skated outdoors. The weather was wild, totally unpredictable: sunshine, rain, wind, snow – at one time or another, we got it all. I'm glad I wasn't in medal contention because I would have got worked up about the wind and how the weather was affecting everybody. The men had terrible weather for their 500-metre races, but for the women, the sun came out and the wind died to nothing. The refrigeration system at the Oval was overheating, though, which delayed the women's 500 metres more than an hour. The track was slow. I ended up placing fourteenth and was happy enough with that.

Bonnie Blair, that remarkable American skater, won gold with a time of 40.33 seconds. Those were the days when Bonnie dominated the 500 metres and the 1,000 metres, and was competitive even in the 1,500 metres. She worked hard, she trained hard, she raced hard – she was a great skater. I had been skating in the same races as Bonnie for a couple of years, watching her, studying how she raced. I was interested in all the top women. They were older and faster. I never put them on a different level, because we all skate together, but I knew I wasn't going to outrace Bonnie Blair. Really, you compete with the people who skate around your own time.

I do remember skating against Bonnie later that year, during that season when something clicked. When she raced, Bonnie kept her hands tightly together, with her fingers almost pointing. If you've

ever seen her skate, or even seen a picture, you'll know what I mean. I remember skating down the front stretch, for the first 100 metres. This was in Davos, Switzerland, at an outdoor Oval, and my hands were cold, it was chilly out, and I remember thinking about how Bonnie held her hands, how she kept them tight. I had a good race, finishing fourth or fifth – and it felt neat to jump to that level, where suddenly I felt closer to challenging Bonnie.

That was the first time I went into that zone I go into, where suddenly I experience a greater awareness. That first time, I felt weird. As I was racing, I was thinking about Bonnie's hands, such a strange thing. I was thinking about how skaters have different styles, and noticing who was in the warm-up lane, and thinking about that. At the 100-metre mark, there are always manual timers in case the electronic timer doesn't work, and I remember hearing beeps, whether it was the watches or what, I don't know. That was the first time I ever experienced that shift, that "outward view," where you're racing but also you're looking around and you're aware of everything and thinking about all of it at once. It felt as if time had slowed down, and if you were showing this in a movie, you would use slow motion.

Not long after that, in December 1992, we were skating a World Cup in Karuizawa, Japan, in a beautiful outdoor rink that doesn't exist any more. It was just below a volcanic hill, and I remember the weather as always sunny, just gorgeous. In my race, I was coming around the last outer, and was expecting the Dutch girl I was skating with to come around on the inside and pass me. As we finished the last corner, I thought, Oh! That's odd. She's not there. And I crossed the finish line. So many pairs skated after us that it came

as a shock when, at the end of the competition, I realized that I was third. I'd won a bronze medal!

Instantly, you think, Maybe I got lucky. Maybe the wind came up for another skater and not for me. But that was it, my first international medal. Later, I learned that it had been five years since a Canadian woman had won a World Cup medal. For the rest of the season, I usually finished in the top six. Now that I had started winning medals, I didn't want to stop. I found myself thinking, Competing is the key. The more international races I skate, the better I'll get. Looking back, I think I was right.

Ah, the life of the "elite athlete." You measure yourself against the best in the world. You get to compete in Holland, France, Germany, Japan. You win medals, you set records. Talk about glamorous! Okay, it's all true. I wouldn't trade my life for any other. Yet sometimes people forget that an athlete's life includes laundry and dirty dishes, just like everybody else's. Most of the time it feels like a cross between a normal life and a constant struggle. Somehow, the public image gets in the way, which is why I keep repeating, Hey! I'm still the same person! I'm still the same person I was last year, and the year before that.

During the long buildup to the Lillehammer Olympics, where finally I was hoping to win the country a medal, I not only became competitive in the World Cup and the World Championships, but I did my share of basic living. In 1988, when I graduated from high school and moved to Calgary to train at the Olympic Oval, I enrolled at the University of Calgary in entry-level everything. Mum always wanted me to have more than skating in my life, and she suggested I move into residence. Obviously, she didn't know a whole lot about residence life.

I had been thinking I would live with some other skaters, people I knew, because, as I've said, I hate going into situations where I don't know anybody. But she wanted me to have friends outside skating, and Dad agreed. I realized that probably they were right. Living in residence didn't do much for my academic performance, and it didn't contribute hugely to my skating, but for meeting people, well, within the first day you know sixty people. Also, ready or not, you have a roommate. I was lucky to end up with Laura Tacey (now Neuls), who to this day remains one of my best friends. That first year, I stayed in one of two huge towers, sharing a room on the second floor of Rundle Hall. Nothing glamorous, I assure you – anyone who knows the University of Calgary knows that.

That first summer, I went home to Saskatoon and stayed with my folks. The following year I moved into Kananaskis residence, another tower, where each floor had three wings. Males and females stayed in different wings, more or less. I became a "wing senior," which meant that I had my own room. Still, a residence is a residence. I had always done well at school, but during first-year university, I got a bit too involved in residence life. My schoolwork

At one and a half, while visiting my Gran in Glasgow, I got mixed up with a radical troupe of British patriots, namely (*left to right*) my sisters Fiona and Ailsa and my cousins Jennifer and Alison.

Four or five years later, another holiday in Scotland: Gran, Mum, Fiona, and I look happy enough, but Ailsa is not her usual cheery self.

That's me in Rio de Janeiro, Brazil, learning to swim. Obviously, we should have stayed longer, because today, although I can get from end of the pool to the other, it's not pretty.

At five, I felt terribly proud of this pretty new dress.

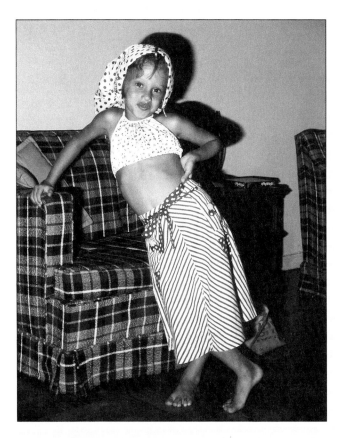

Blame it on Rio, where we played dress-up. I wanted to look older and my sisters were happy to oblige.

I can't believe I was such a shrimp! But this was me in 1981, skating on Wascana Lake in Regina, bound for my first national championship.

In the Saskatoon dressing room, after a weekend of racing, I look exhausted. I don't know which competition this was, but judging from the trophy on the bench beside me, things went all right.

During my teenage years, my dog, Chinook, was my best buddy. She knew all my secrets.

In 1989, I travelled to Heerenveen, Holland, as an alternate in the World Sprint Championships. Along with other young skaters, I was heading for the Junior Worlds in Kiev.

This was taken for Metropolitan Life, my first major sponsor.

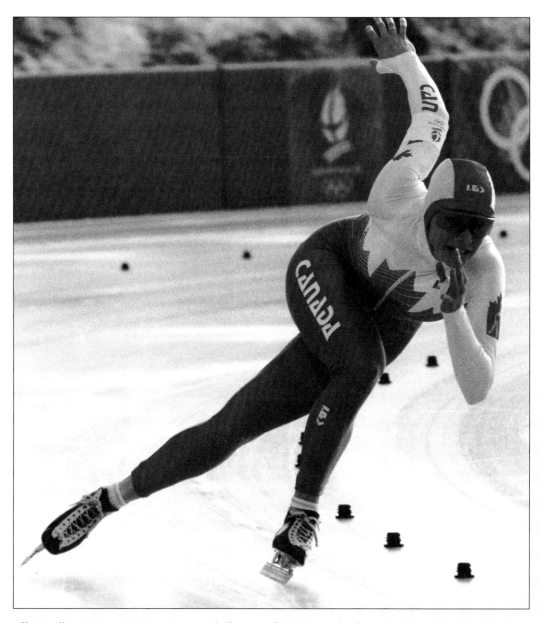

Albertville, France, 1992: For speed-skaters, these were the last outdoor Olympics. Back then, as you can see, I was still wearing socks in my skates. And look at those clunky glasses! Today, mindful of wind resistance, we're much sleeker.

Opposite top: In Albertville, I hung out with fellow skater Shelley (Rhead) Skarvan. We had so much fun travelling together. Shelley lives in Switzerland now, but she's still a really good friend.
Opposite bottom: In Lillehammer, just before that 500-metre race, some overly optimistic Canadians posed in the stands – (*left to right*) Fiona, Ailsa, Bart, and me. Never again would we be so young and innocent.

At the Lillehammer
Olympics in 1994,
I got off to a good
start in the 500 metres.
Here I am blazing
down the front stretch
towards the first corner,
skating strongly and
about to receive the
worst shock of my life.

suffered. But I was eighteen, had a good time, and I got that out of my system. As my mum says, some things you learn the hard way.

To remain in residence you had to be a full-time student, which meant taking at least three or four classes, and that I managed. It's a good thing, too, because under the carding system, the federal government was covering most of my university expenses. Back then, a "carded athlete" got one of four cards: A, B, C, or D. To get an A card, you had to be ranked top eight in the world in your sport. To get a B card, top sixteen. For C, you had to be ranked top twenty-four or competing in World Championships. And D was for developing athletes, a junior card.

A couple of years ago, the government simplified the system, so that carded athletes receive either a junior or a senior card, period. But now I hear they're making more changes, and who knows how the system will end up? Each sport is allowed a certain number of cards, and that number differs from one sport to the next. Basically, a priority system determines who gets carded: Olympic team, World Championship team, World Cup team, and so forth. But within that, each sports federation has its own rules.

Anyway, because I was a carded athlete, the federal government paid my university tuition, as well as nutrition-consulting and testing costs. My parents covered residence and living expenses. Then, in second year, I had to drop some classes because the skating team went to Europe for an extended period. These days, we go to Europe for a competition and come straight home. Back then, we would go to Europe for ten weeks at a stretch. We would leave in January and return home in March, even if we had five weeks between competitions. It's unbelievable, when you think about it.

At that point, I had to put school on hold. I would take classes when I could, maybe attend something in a spring session or do a course by correspondence from Athabasca University. But mainly, I focused on skating. That's why I had moved to Calgary in the first place – to train with the national team at the Olympic Oval. Right from the start, with possibly the fastest ice in the world, the Big-O attracted skaters from around the world. During any given World Cup season, skaters from a dozen countries train and compete in Calgary.

By 1997–98, when the Oval was a decade old, more than 100 speed skaters were participating in various long-track programs. In July and November, you get three annual development camps: Top Blade Camp, Western Provinces Camp, and Fall Provincial Training Camp. The spring of 2002 brought the inaugural Absolute Speed Camp. Meanwhile, between early October and late March, you've got a weekend race series that includes thirty days of racing. Did I mention that the Oval is a busy place?

Even before I joined the national team, back when I was in my teens, I attended some rigorous training camps. Once I got to Calgary, the training did get more intense, partly because I was at the bottom end of the national team, just another youngster coming aboard. Fact is, I've always trained hard. Any number of how-to-train books, some of them fat and authoritative, can tell you what that means in all-too-painful detail.

On the technical side of speed skating, you have to learn how to position the body, how to align the head, the shoulders, the hips. And you continue to work on that, just as you continue to practise your start, no matter what level you reach as a skater. You also learn how to skate the straightaway. With the longer distances, you'll see

people put both arms behind their backs to conserve energy. When they reach a corner, they'll start swinging the right arm to keep the rhythm going. In the sprints, you're using both arms all the time. My own shoulder comes up very high, and that's not the best form – but it's the way I've always skated, and it's a very hard thing to change.

As a sprinter, you pay special attention to skating the corners. You learn how to take each leg through its maximum extension, how to use your blades to advantage, how to enter the middle of the turn and start your crossovers, maintaining a lean and keeping your hip in. You stay on the edge of your skates, and you're supposed to have only one foot on the ice at a time, pushing, and the motion is tick, tock, tick, tock, all very fast but in a smooth rhythm. You want to use those corners to build speed. To get it perfect would take, well, who knows? After more than twenty years, I'm still chasing the perfect race.

The technical demands of speed skating tend to surprise new-comers. But in addition to technique, obviously you have to develop not just speed and power but endurance. The season starts in May with dryland training, and for endurance, most skaters prefer cycling to running. I don't care much for pedalling up hills, much less up and down mountain passes. Who does? To the west of Calgary, you've got the foothills and then the Rockies, so for years I cycled mostly to the east, spending hours each week powering along the two-lane highways. Lately, given road construction and increasing traffic, I have been heading west more, out around Bragg Creek.

Besides cycling, I'll run intervals or else do "fartlek" workouts. The word "fartlek" means "speed-play" and the concept is Swedish. Basically, it means doing change-ups. We'll go jogging for ninety minutes, but we'll stop every few minutes to do "imitations" of

skating or ferocious calisthenics. Oh, and let's not forget weight training, with lots of curls and presses and pull-downs and even more sit-ups, extensions and squats. In other words, our dryland training includes a little bit of everything – running, jumping, and standing still.

Early in the season, easing into it, we'll work out three or four hours a day. But when we're rolling, usually we'll train six hours a day in two sessions. The schedule varies so much that it's impossible to generalize. Priorities for a given three-week stretch might be weights and aerobic capacity, or else some other combination of power, anaerobic capacity, and lactate capacity. And so the workouts vary. As well, if the weather turns ugly, we might postpone a scheduled fartlek workout until the afternoon, and instead head to the weight room. Deeper into the season, we'll train six hours a day, six days a week, and take Sundays off.

My favourite part of dryland training has been attending the camps. We didn't go in 2001, but for several years in a row we went to a training camp at Fortress Mountain in Kananaskis Country, out in the mountains west of Calgary. During the winter, Fortress is a ski resort with special appeal for snowboarders, because it gets lots of powder. But in summer, we would go out and use the lodge. It's situated 7,000 feet above sea level, so this would be part of our altitude training. Most skaters would stay in the condos, though usually I would put a camper on the back of Bart's truck and stay in that.

At Fortress, you go on rugged hill runs, and you tackle them in a certain sequence to boost your various systems. These runs are tough workouts, and often you'll see people, well-conditioned athletes, sitting on the side of the hill, and they won't be looking good.

Half the time as you run, you're fighting not to be sick, and people don't always win that battle.

What I really like is the diversity of going out in a large group. Sure, we're all skaters, but here you have not just the national team but the whole Calgary Oval program. You get people who are on provincial teams, and they're working really hard, and maybe they're better than you at a hill run, or you're competitive with them, and yet everybody's cheering everybody else on. And just because I've won a gold medal doesn't mean I will be better than somebody else at a hill climb. We're all training together, and I love that. I love being just another athlete. Also, I love that feeling of being pushed to the limit, where you're about to start crying because you're so exhausted and you feel so horrible. People respect each other, you help each other, you push each other, you cheer each other on. And in dryland training, that's what I love most.

Not surprisingly, most skaters prefer to train on the ice. In Calgary, the ice disappears from the Oval in April, but by July, it's back and so are the skaters. Depending on the individual situation, we'll skate either short or long intervals. This means you skate hard for a certain distance, rest for a short, fixed period, then repeat the hard skate. And you do that again and again and again. When we get closer to racing, then we do more tempo-training, which involves skating at or near top speed, but very controlled and achieving certain heart rates. Coaches say this increases both stamina and mental toughness, and I believe it. When I'm focusing on aerobic training, I keep my heart rate at around 160.

I don't think of myself as a pure sprinter, because I am competitive not just at the 500 metres but also at the 1,000 metres. Still, I train mainly as a sprinter. Early in the year, usually I focus on endurance

and stroke mechanics. Because we have very sophisticated coaches, the workouts vary a great deal, but of course I pay attention to starting, accelerating, turning, maintaining speed, and finishing. I might do a series of all-out sprints at anywhere from 50 to 400 metres. Or I'll do sprint accelerations, skating a buildup 200 and an all-out 100, followed by a buildup 100 and an all-out 200.

Or else I could do a fartlek workout as adapted to ice. I might warm up by skating five easy laps, and then do four laps of 250 metres, varying the buildup and sprint each time, and with a long rest between laps. Then I might sprint two sets of 50, two sets of 75, and two sets of 100 metres, resting briefly after each set. Then might come four fast accelerations of 250 metres, followed by 50-metre standing starts, and then two timed 100-metre starts. The variations are endless.

The coaches have organized our workouts into three-week blocks. These change according to whether we're focusing on the aerobic system, the anaerobic system, on power, on endurance. Whatever the focus, often we work until we can't continue. Most people don't understand what athletes go through. You push your system to the limit, to the breaking point, so then you feel drained, and hormonally you're low, everything is low. Eventually, you start to build. Every year, though, I have at least one bad month when I'm thinking, I don't know if I can do this any more. I don't know if I can go on.

That's when my Scottish background kicks in, or maybe it's just my own stubbornness. I don't know, but always it comes down to "No way I'm going to quit now. Just no way." If I find myself facing a tough workout, I focus on my goals. I don't ever want to be in a situation where I'm asking myself, What if? What if I had pushed

myself in training instead of quitting? So that's what you do. You think of your goals and push yourself.

Meanwhile, you're trying to live something like a normal life. And in those early years, that meant attending university and holding down summer jobs. In high school, I had worked part-time for my dad as a secretary, and after first-year university, I did that again. Also, I looked after some children in a before-and-after-school program. Later, at a restaurant called the Red Lobster, I did some waitressing. But the summer after second-year university, I stayed in Calgary and got a job selling vacuum cleaners. They were high-end vacuums, quite expensive, and somebody set up appointments in advance, so I didn't go door-to-door.

I sold a few vacuums that summer, but I have always believed I sold more than the company admitted. And that has bothered me ever since. Because although we were sales people, we never really knew whether we'd made the sale. After we had visited, the customer would call the company, and then the company would report the sales and you would get your percentage. But a few odd things happened, and I think I sold more than I was credited with. I sometimes think I should have gone back and talked to a few people. Of course, you never do, not if you're like me – instead, you move on.

So that's one aspect of the "glamour" of the athlete's life. But it's hard to argue that international travel isn't glamorous. For sure, it's a privilege and a wonderful opportunity. Travelling in Japan is so expensive, for example, that once I stop skating, I doubt that I'll get there again. To get there at all is quite wonderful. I realized early on that I was better prepared than a lot of athletes to travel, because as a child I had visited Scotland many times, and I had even spent that year in Brazil. In high school, I had travelled there yet again, just

Dad and me, and I remember being in Rio, hanging out on the beach and then going for steak and fries. But we ate a lot of other foods, too, and so those trips prepared me. I knew it was okay to try different meals, and when I got to Kiev, I didn't freak out when I learned they weren't serving roast beef, potatoes, carrots, and milk.

Even so, being away from home for eight weeks at a stretch can be a pain – especially when you're constantly with the same group of people. With most folks, as probably you've noticed, there's a limit to togetherness. Usually, though, you get to know people well enough that you can say, Okay, please, no offence, but I just need to spend a little time alone.

On some occasions, even for the hardy, travel can be scary. I remember being in Davos, Switzerland, when the Gulf War broke out. We were going to Collalbo, which is in the mountains in Italy. And for some reason I woke up during the night and couldn't sleep, and I ended up phoning home. And I remember my dad saying, "Have you heard?" And I said, "Heard what?"

The Americans had started bombing Iraq. I remember turning on the TV and getting quite upset. One by one, the other girls came out into the living-room area, and soon we were wondering, "Okay, what now? Does this mean we'll be going home?"

But we did not go home. We went ahead to Collalbo. The American skating team was already there. At the Oval in this little Italian town of maybe 200 people, the police turned up. They told the Americans that, for safety's sake, if they travelled into the nearby town of Bolzano, they shouldn't wear their team jackets. One of the Canadian guys asked, What about us? The police said, The same applies to you, just in case. Don't wear your team jackets

into town, and if you are going in, let us know in advance, so we can keep an eye out.

At our hotel, we had a television set. We couldn't get any English-language channels, of course, but those of us who understood French could make out what was happening by reading the Italian news on one of those channels that scrolls the news in printed form. Because French and Italian are so similar, both Romance languages, we could get the gist of what was going on. And then you'd see the pictures on another channel. A lot of people got quite stressed, though, because they couldn't understand much at all. This was an international crisis, no question, and some people were saying, Well, we're not safe here and we should go home. Every day, one of the coaches would phone the Canadian embassy in Rome: "Should we go home?" "No, you should stay."

However, with the police around, and talking all the time with the Americans, whose country had declared war, the stress level kept rising. We Canadians had organized some training races with the American team. Early on the scheduled morning, we went to the Oval and began warming up. We skated and skated but the Americans didn't show up. Where were the Americans? We thought, This is strange – strange and scary.

One of the guys went to the hotel where the Americans were staying, and he discovered that they were gone. Gradually, we learned what had happened. Secretly, during the night, the United States government had flown home all American athletes from wherever they were around the world. The athletes themselves hadn't even been told, because the government didn't want anybody to know. During the middle of the night, some high-ranking officials

had come to the hotel, rounded up the team, and got them on planes to go home.

Then we thought, "Okay, the Americans have gone home. Maybe we should go home, too." We checked again with the embassy, and they said, No, don't go home. Why go home? This is Italy, not Iraq. You're not in any danger. So we stayed in Europe and kept skating. And why not? On one level, that decision made me feel good, because it reminded me that I'm a Canadian. At the time, the whole situation was stressful and unpleasant. Looking back, maybe the experience sounds glamorous. But I could have lived without it.

Speed skaters take time off from training in the spring, usually one month or six weeks, to let the body recover. But during the buildup to the Lillehammer Olympics, in the summer of 1993, I decided that instead of taking time off, I would return to one of my first sport loves, track and field. As a girl, although I'd never joined a track club, I'd gone to some meets and won some races. I had sometimes wondered, What if? Without belonging to a track club, I had been quite successful. But what if I did join a track club and train? What would I be able to accomplish?

In high school, my main focus had been speed skating. But also I had played soccer in the fall, and I had run cross-country and

done track, primarily the hurdles and the sprints. And back then, my skating start had been faster. So I thought, If I do track, maybe that will make my start faster. In 1988, when I graduated from high school, I had still hoped to make it to the Canada Games the following year. My plan had been to talk to the track coach at the University of Calgary, Les Gramantik, to introduce myself and get involved. I did meet Les, but once I settled into Calgary and started taking university classes and skating, I didn't have time for track or anything else.

Back home in Saskatoon that first summer, I didn't do much track. Obviously, I wasn't going to the Canada Games because I hadn't qualified. But it was still on my mind, weighing on me, that I hadn't done everything I could in track. I hadn't finished something I had set out to do. So early in 1993, back in Calgary, I again approached Les Gramantik. At this point I had been to the Albertville Olympics and had achieved some good results in World Cups.

Also, I had talked with Lyle Sanderson, the track coach at the University of Saskatchewan. He had coached Diane Jones Konihowski, that great pentathlete and three-time Olympian. I had told Lyle that I would like to do some track and try to qualify to represent Saskatchewan at the 1993 Canada Games. Lyle said great! And he convinced me to take up the heptathlon, which involved running, throwing, and jumping, because with seven events, the strength and endurance I had developed skating would compensate for any lack of technique in specific events.

In Calgary, even though I would end up representing Saskatchewan, Les Gramantik approved this plan and invited me to attend his training camp in Tucson, Arizona. After the 1992–93

World Cup season, I had two and a half weeks off from skating, and then I went to Arizona and started training for the heptathlon. The seven events are 100-metre hurdles, 200 metres, 800 metres, javelin, shot put, high jump, and long jump. I had to work hardest on the jumps, because they were my weakest events.

Les Gramantik is one of Canada's great coaches. In 2001, he coached this country's World Championship track team. Anyone who has trained with Les will tell you that he expects a lot, and that he'll yell at you if you don't work hard. And people who don't know Les well are usually scared of him. Les is a teacher, and his attitude is, if you're not going to work hard, you're wasting my time, so get out of my class. He's originally from Hungary and very old school, but amazingly effective.

Tucson is a tough training camp, but also it's fun. That summer, I met a great group of people and we're still good friends. And I have to laugh, looking back, because if somebody did something wrong, Les would yell . . . unless that somebody was me. So people said, We're going to stick with you, Catriona. They had figured out that Les knew I was mainly a skater and didn't want to scare me off.

Also, of course, I did work hard. I think that, as long as you work hard, Les respects that. You don't have to be a world champion. But you do have to respect him. And I think Les is one of the best coaches in the entire world – I don't know how he does it, but he makes you want to work hard. You want him to be proud of you. You're not doing it for that reason, and yet it's one of those situations. When Les is excited for you, that's so, so great.

With the help of Les Gramantik, I did qualify to compete in the Canada Games. They're modelled on the Olympics, and they're

held every four years. There's an opening ceremony, a closing ceremony. The Games last two weeks. You stay in residence. For a lot of athletes, the Canada Games are a major step towards the Olympics. For others, competing there is the pinnacle. That's it for them in their sport, and they're rightly proud of that.

In 1993, the Canada Games were held in Kamloops, British Columbia. I competed for Saskatchewan not only in the heptathlon, but also in the hurdles and the relays. I didn't win any medals, but I made the finals. Also, I made friends with some great people and felt very happy with how it went.

I enjoyed the experience so much that the next summer, I went back for more. I took two and a half weeks off and went to Tucson. This time, once or twice, I got yelled at, and everybody said, "Ha! The honeymoon's over! Les realizes that he's not going to scare you off, so now he can yell at you, too." We shared a good laugh about that.

Les could be harsh, but he knew when to push you. Yet, when you were having a bad day, he would put his arm around you and say, "You know what? You're not doing yourself any good here today. Why don't you head home?" He was a great coach that way, because he knew what made you tick. One particular time, I was having trouble with my shins. I had shin splints. Les was watching me practise the high jump, and he came over and said, "What's wrong?"

You never want to tell Les anything, because you want him to be proud of you. You don't want him to think you're weak. So I said, "What do you mean?"

"What's hurting you?"

I said, "Nothing's hurting me."

"No, tell me what's hurting you."

"Okay, my shins."

And he said, "Fine, you go and do such and so."

Les is very perceptive. He would watch how you react and notice if you made a face or tightened your fist or whatever. Really, he is an amazing coach with a great work ethic. I learned a lot from Les about how to push myself, and also how to deal with frustration, because I was working in an area I hadn't yet mastered.

In the summer of 1994, I competed in the national track championships, which were held that year in Victoria. The summer after that, I repeated the cycle once again. After training in Tucson, I went to the nationals in Montreal. I really enjoyed the whole experience, especially the heptathlon, because it happens over two days. Once you start the day, you don't leave the group. You're competing with other girls and yet it's very different than an individual track event, because you get to know each other, and everybody is mutually supportive, because you're together two whole days.

Some of these girls were outstanding athletes and were competing in the nationals while working towards the Olympics. They were so supportive. I didn't arrive with the attitude, Hey, I've been to the Olympics, I'm really something. I went in and was competitive in some of the events, and I worked hard, and I think the other athletes respected that. At the same time, I admired them and looked up to them because in their events, they were a lot better than I was.

By the end of the summer of 1995, I had accomplished what I could in track. I had competed in the nationals, and also at the Canada Games in Kamloops, where I had run well in the 400-metre relay and placed eighth in the heptathlon and hurdles. I decided, Well, that's not too shabby, since for me, speed skating comes first. I

began to realize that if I wanted to be all I could be in speed skating, I would have to give it some honest summer training.

That realization came after Lillehammer.

Late in 1993, during the buildup to that Olympics, I felt great. Coming off the track training and the Canada Games, I was as lean and fit as I've ever been. I'd ended the previous World Cup season ranked fifth in the world in the 500 metres. I was skating well. One month before the Olympics, I won a World Cup bronze in Milwaukee. At Lillehammer, American skater Bonnie Blair was pretty much assured of winning the gold, but I thought that if I skated a perfect race, I could end up on the podium too.

During the final weeks before the 1994 Games, I brimmed with confidence. "You've got forty seconds and that's it," I told one reporter. "There's no second chance. If you slip, that's it. Too bad." Obviously, I was thinking, Sure, somebody might slip and fall. But me? Me slip and fall? That was one thought I never seriously entertained. Okay, we all know we're going to die some day. Still, most of us never imagine it happening. In that same way, I never really entertained the idea of slipping, much less of falling. Don't be ridiculous. It wasn't going to happen. No, no: I was going to skate and win an Olympic medal.

Not only that, but my then-boyfriend, Bart Doan, was coming to Europe for the first time, and he would see me win that medal. He was flying from Calgary to Frankfurt, and taking the train all the way north to Norway. He would change trains in Lillehammer and carry on to Hamar, where the skating was being held. Hamar is a small town not unlike Banff or Mont Tremblant without the mountains – much more intimate than Lillehammer, and very nice.

My family was already in Hamar, so my sister Fiona and I went to the train station to meet Bart's train. And we thought, no way he's going to be on that train, because this was his first time in Europe and there had been any number of places where he could have missed a connection. But when the train pulled in, suddenly Bart was on the platform, practically the first person off the train, swinging along towards us wearing this big grin. "Bart! You made it!" we shouted.

"Of course I made it." He gave me a big bear hug. "I said I would, didn't I?"

The plan was that after the Olympics, the Canadian team would go home to Canada. Then, twelve days later, the speed skaters would return to Europe for a World Cup competition in Inzell, Germany. Bart and I had worked out a variation. Instead of going home, I would travel around Europe with Bart. We had bought train tickets, and we would just enjoy those twelve days together. Then I would hook up with the team in Germany. Considering what happened, and how the Games went for me, this plan turned out to be a stroke of genius. Sometimes you don't want to put on a brave face and talk to the media.

As for what happened, exactly, on February 19, 1994, who knows? Lillehammer was the last Olympics before everybody moved onto the so-called klap skates (I'll talk more about them later), and we sprinters were skating a single 500 metres. I was racing against Franziska Schenk of Germany, which I thought was a perfect pairing, because we were both quite fast at the beginning. Sure enough, we both started fast and flew down the front stretch. We hit the first corner and I'm thinking, Go deep, stay low, first

crossover, stay low, stay low, and just after the second crossover, that's when I fell.

Sometimes you know why it happens. Sometimes you don't. Did I catch an edge? Did the ice break under my skate? I don't know, and you can't tell from the video. Down I went, boom! I slid into the barrier in the corner and that was that. Franziska raced on. She won the bronze medal, and that made it harder because we had been paired together. I couldn't help thinking, What if I hadn't fallen?

Bonnie Blair won gold, and Susan Auch, one of my Canadian teammates and training partners, took silver. We were all happy for Susan, but I was rocketing up and down – happy for Susan one minute, and upset for myself the next. You don't want to take anything away from anybody else, but it's not always easy to control your feelings. It was hard for my family too, and for Bart, because they were sitting in the stands, watching, and they felt disappointed for me. I felt bad because they felt bad, and you get into this spiral going down and down and down.

I remember Kurt Browning, one of this country's greatest-ever figure skaters, coming over to me in the village, and giving me a hug, and saying, "I know how you feel." I knew he was one of those who really did. Kurt made me feel a bit better, because his kindness came from such an amazing champion. And later, Diane Jones Konihowski, who is something of a role model for me, reminded me that the great skater Dan Jansen had fallen at an Olympics: "It happens to the best of them."

At some point, of course, consolation becomes impossible. The night after the fall, I went to the house where my parents and sisters were staying and remained with them. But I had more races to

skate, both the 1,000 metres and the 1,500 metres, and I couldn't afford the luxury of sitting in a corner and feeling sorry for myself, however much I would have liked to do exactly that.

A couple of years later, an article in a British newspaper said that after Lillehammer, it took me months to get back on my skates, and that even the mention of crashing would plunge me into a depression. Well, that's not true. At the Lillehammer Games, I skated my other two races, and afterwards, I finished the World Cup season. After that, I took the usual break, because even speed skaters need some time off the ice.

It is true, however, that I didn't feel like giving in-depth interviews about what had happened, or speculating about what might have been. But think of Bart! Together, we had planned a romantic holiday, the two of us rambling around Europe, and now Bart had to deal with a basket case. For sure, I felt devastated. We forged ahead anyway, according to plan. We took the train to Copenhagen, and then on to Amsterdam, where we visited Anne Frank's house and took a boat ride through the canals. Then on to Paris! We ate baguettes on the banks of the Seine, then took the elevator as high as we could in La Tour Eiffel and stood looking out over the City of Lights.

Bart and I had been dating for more than a year, but travelling around Europe, we learned a lot about each other – partly because, as a result of my falling at the Olympics, I plunged into an emotional maelstrom. For years, I had worked to get to that race – and then to fall? To fall when I had never fallen before? It seemed so weird. I couldn't make sense of it. I kept coming back to the fall, going over it and over it, trying to figure out what it meant. Why me? Why would I be the one contender to fall? What did my falling mean?

"I don't know what it means," Bart said after I'd asked him six times. "My dad says that God works in mysterious ways."

I knew that Bart's dad was a born-again Christian, and that he served in an Alberta ministry as a pastor, but I said, "You're not telling me this is God's work?"

"I don't know, Catriona. You keep saying, 'Why did this happen? What does it mean?' All I can say is, maybe God's trying to tell you something."

"What could He be trying to tell me?"

"Catriona, I'm not a pastor. Maybe 'Pride goeth before a fall'?"

"You mean God's punishing me? Because I expected to win a medal?"

"Not punishing you. I don't know. Maybe trying to lead you somewhere."

"That makes no sense, Bart. That's no answer at all."

In Europe, that's where we left it. But whatever "it" was, it came home with us. I entered what I now think of as my dark night of the soul. That dark night began in Hamar, Norway, on February 19, 1994, when I fell in that race, my best distance, and it lasted several months. All that time, I found myself wrestling with questions I had never asked before. "Why am I training like this? Working so hard? Do I want to work like this for another four years, just so I can fall in another Olympics? Do I really want to continue? Is this what life is all about? Is this all there is?"

III

THE BACKSTRETCH

10

❖❖❖❖❖

Early in 2002, *Maclean's* magazine published an article called "Living the Faith," a cover story that featured profiles of "nine Canadians who put their beliefs into action." The article paid tribute to individuals in multicultural, multi-faith Canada who are "committed to practising their religion not just on religious holidays but in their daily lives." It reported that more than eighty per cent of Canadians believe in God, three out of four pray at least occasionally, nearly half claim to have experienced God personally, and two-thirds believe in life after death.

My own favourite profile was that of a businessman who became a born-again Christian and rebuilt his life after being brought low. He discovered that the Bible was an "oasis of sanity," and that he himself was not the centre of the universe, God was. I enjoyed that story because it reminded me of my own.

Lillehammer laid me low. You build four years of hard work around a single race and then, boom! Something goes wrong and you've got nothing to show for it. Afterwards, as I've mentioned, I found asking myself, "Why did this happen?" The thought of training four more years for another shot at a medal was depressing. Tough to deal with. Beyond that, I consider myself a decent human being, and I couldn't understand why such a terrible thing had happened to me. I began looking around and realizing that terrible things happen to all kinds of good people. And that made me wonder. You could say I started searching for answers.

When I was growing up, I went to church and Sunday school until sports demanded just too much. But really I didn't know what being a born-again Christian meant, because to me, the term "born-again" suggested a dance-on-the-tables and sing-and-shout-from-the-rooftops sort of faith. And even though Bart and his family were practising Christians, he and I had never talked about my taking that step. Really, if anybody in his family had tried, I would have turned and run the other way, because if anybody tries to push anything on me, I go the opposite way – that's my personality. So if somebody told me, "You have to skate," almost without thinking I'd say, "No, I don't." That's always been my way – stubborn to the point of rebelliousness.

So Lillehammer was how it started. Something like that happens, and you find yourself asking, as I did, "Why me? Why did I have to fall? Am I being punished for something?" I think most people would ask questions like those. Then, shortly after I returned to Calgary, I was driving along a main thoroughfare, Memorial Drive, when I noticed a sign on a lamppost. It said AIA, Athletes in Action, and I jotted down the phone number. I really do believe I was led to

that sign, because believe me, I don't usually call strange telephone numbers to make inquiries.

Even now, I don't know why I called. I guess I felt, "I'm an athlete, and somehow, that sign applies to me." So I called the number, which was totally out of character for me. Then, even stranger – remember, I'm shy! – I went and met some of the people at Athletes in Action, which is a ministry of Campus Crusade for Christ. I met Harold Cooper, Steve Sellers, Rodd Sawatzky. I ended up sitting down with Harold, and he went through the gospel with me, but it was all too much at once. He talked about Christ dying and being born again, and how baptism symbolizes death and rebirth, so you're born again into a new life of faith. He outlined what it all meant, and he asked me if I wanted to become a Christian: "Do you want to make this commitment now?"

Whoa, wait a minute! I said, "No, I want to talk this over with Bart."

By now, Bart and I had been going out for two years. We had met at the Olympic Oval in Calgary, where he had a job making ice. I remember seeing him riding around on the Zamboni, and when you're a skater, inevitably you get talking to the guys, who are usually on shift three at a time. Basically, they're always around the ice, and we're always around the ice. I remember thinking Bart was cute, and then reading something I was sure referred to Bart in the university newspaper, *The Gauntlet*. They had a feature called "Three Lines Free," where people would write in saying silly things, trying to meet people, whatever. Somebody wrote in asking about the "cute new guy" driving the Zamboni at the Oval. And I remember thinking, Aha! I know exactly who she means.

Bart can be really funny when he talks about how we met. He says that when he started working at the Oval, he thought he had died and gone to heaven. Suddenly, he was surrounded by athletic babes skating around in what he describes as "little more than bathing suits showing off every line and curve." If you don't wear a skinsuit, of course, you slow yourself down with so much wind resistance that you can't even compete. So Bart liked the look of the skaters, generally. But he's really quite shy, too, and we were both going out with other people. For a long time, maybe a year or more, we would see each other at the Oval and one of us would say, "Hi," and the other would say, "Oh, hi." And that was it.

But then, after four years, my relationship ended. And Bart had just broken up with his girlfriend, someone he had gone out with for four years, too. We got chatting and one of us, I guess it was me, said, "Hey, one of these days, we should go for chicken wings and a drink." Bart had recently cut his lip badly, either steer wrestling or playing hockey, and he said, "Ooooh, wings, I don't know. Wings will sting this cut lip." Anyway, he decided to tough it out, and we agreed to meet at Nick's Steak House, which is on Crowchild Trail and not far from the Oval.

Bart likes to describe what happened as "our disastrous first date." When it came to it, I got nervous, because suddenly I was going to meet this strange guy. So I said to a couple of girlfriends, "Hey, why don't you guys come with me? We'll go early and have something to drink and it'll be fun." They said no, but I kept bugging them: "Come on, you guys! Please! Please!" So finally they agreed, because I kept after them, saying we'd have a good time, it would be really fun, and maybe this Zamboni guy had a friend. By the time

Bart arrived at Nick's Steak House, we'd had a few drinks and were laughing and giggling and having a great time. The way Bart tells it, he thought, "Hey, I can take a hint."

So he sat brooding over his chicken wings, thinking, "Well, I won't phone her again."

At this time, I had been living nearby with my sister Fiona. She and her boyfriend, Kevin, were planning on getting married and moving to California. So I was going to move out of the place we'd been sharing into a condo that my dad owned. It was not far from the Oval, and just across the street from a shopping centre called Market Mall. Meanwhile, at Nick's Steak House, before Bart left, I told him that the next day we had to move some heavy stuff into the new place, fridges and stoves and bedroom furniture. I said, "Give us a shout and maybe you can come and help Kevin with the heavy stuff."

Bart said he would call, but he didn't. He didn't answer his phone all that day, either. So Kevin, Fiona, and I moved all the heavy stuff. And Bart says now, explaining how he felt, "Well, look. I'm stood up on a date, or somehow the date never happens, and then I'm going to come and spend my Saturday moving heavy furniture?" And he slaps his forehead. "Was I born yesterday?"

Anyway, somehow we got over that, I don't remember exactly how, though Bart says I called and apologized. We ended up going on a date without my girlfriends, and then we went on another date after that. At this time, besides training, I was also working as a waitress at the Red Lobster, so I was really busy. But I began to realize that if I didn't see Bart for a while, I would miss him. And I began to think that maybe I liked Bart Doan a lot more than I had

been letting on. Obviously, he felt the same way. We decided to get more serious, or maybe it just happened, but we became, as they say, "boyfriend and girlfriend."

Bart is three years older than me. His dad, Phil Doan, used to be a rodeo cowboy. In 1972, he won the Canadian steer-wrestling championship, and two years after that, he was the overall Canadian rodeo champion. And this tradition goes back over time. Bart's grandpa, Muff Doan, won the Calgary Stampede steer-riding championship in 1944. Bart grew up on the Doan family farm at Halkirk, ninety minutes east of Red Deer, which is a small city halfway between Calgary and Edmonton. His grandma still lives on the farm, though one of his uncles runs it.

Bart works winters at the Oval, making ice, and summers as a steer wrestler. This means he gets on a horse and roars out of a chute, racing along to the left of a steer. On the other side of the steer, a "hazer" rides along, whose job is to keep the steer running straight ahead. When Bart comes off the horse, he hangs off its side using his left arm, like a trick rider. He grabs the horns of the steer with his right arm, and the horse is trained to keep running, so Bart's feet fly out in front of him before they hit the ground. Bart digs in his heels, hauls the steer over his hip, and wrestles him to the ground. When the steer is lying on its side with all four feet pointing the same way, that's your time.

To the untrained eye, it looks as if the rider bails off and hopes for the best, but steer wrestling is in fact precise and technical. Bart would love to compete in the Calgary Stampede or qualify for the Canadian finals, but that takes a lot of time and dedication, and he has been so involved in supporting my skating career that it just hasn't been possible.

Hockey is Bart's first love, though. His cousin Shane Doan plays in the National Hockey League with the Phoenix Coyotes, and Bart himself played both Junior A and then senior hockey all over Alberta. Some day, he might like to coach hockey for a living. During the past couple of years, in partnership with a visiting Czech hockey coach who is also Hayley Wickenheiser's boyfriend, he has been doing some skills development work with younger players. He doesn't yearn to coach in the NHL, but to coach a national team is something he would like to do, because when you work with the national team, you're working with terrific players, and helping them develop, which he really enjoys.

So this was the guy I started dating. Bart would jump off horses at forty kilometres an hour, and that would be okay. But then he would watch me move to the line for a big race and he would get so nervous he could hardly stand it. There's something genuine about Bart that I found attractive. Okay, I was falling madly in love with the guy and didn't know it. And on his side, he'd hate to admit it, but the same thing was happening.

After Lillehammer, and then after contacting Athletes in Action, I was going through a questioning period. During that time, I would talk with Bart's dad, because besides being an ex-rodeo champion, Phil Doan is a pastor with World Cowboy Ministries, which is huge in the west in both Canada and the United States. In Calgary, the Cowboy Church is set up in the Ranchman's Club, and I'd always thought that was cool, that you could go to church in a bar. It's more of an outreach, really, and a lot of people wander in off the street.

It was definitely nothing like the Scottish Presbyterian Church I had known as a girl. It was evangelical, and everybody was twenty or thirty years older than me, and it was all very interesting – a whole

different culture, and almost part of being a cowboy. Bart's extended family is well-known in both athletic and Christian circles, and they run the Circle Square Ministry out in Halkirk. By now I felt comfortable talking with Bart's dad about religion, and I would challenge him, because you read something in the Bible and think, Well, come on, nobody can change water into wine. That doesn't make sense. Bart's Dad, being who he is, loved my searching questions.

This questioning period of mine, really a search for meaning, lasted into the autumn of 1994. Meanwhile, partly because of this agonizing, Bart and I were having our ups and downs – a typical dating relationship. Were we going to stay together? If so, where were we going? Did we want to get married or what? When we talked about my becoming a Christian, and actually committing myself, I discovered that this was important to Bart. We'd been going out two years and I hadn't known! I don't think Bart himself had realized. But it was clear that he would not have wanted to marry someone who had not made that commitment.

After visiting Athletes in Action, I put the idea of becoming a practising Christian on the back burner for a few weeks. I guess I was trying to postpone it. But finally I brought it up: "Bart, is this something that's important to us? Let's sit down and talk about this."

Bart had been careful not to pressure me, because he knew me well enough by now to know I'd rebel. But now we talked, and I told him, "Yes, I want to make that commitment. I am ready to become a Christian." So at that point I decided to commit my life to Christ.

This was during the autumn of 1994. I went through a spiritual rebirth.

But it was funny, because you think that, all of a sudden, your life will change. You get struck by lightning, you have this huge revelation – only it was as if nothing changed. Then skating season started, and during training, I injured myself. Somehow, I fell and caught my foot in the mats that run along the ice. I didn't actually sprain my ankle, but the inside of my heel, near my Achilles tendon, felt really sore. It felt especially painful to bend my knee forward, and in speed skating, you have to keep your knee in front of your toes. The angle in the ankle is forward. You don't want to be at a ninety-degree angle from ankle to knee, but closer to sixty degrees forward. Leaning forward like that really hurt the inside of my foot.

I started doing physiotherapy and kept hoping for a turn-around, but I found it painful even to put on skates. The World Cup season started and I went to Japan to race, but my foot hurt so much that I had to pull out. It was just not getting better. I came home, I went to physiotherapists, and they said, "You need a break from being on skates." So I missed the Canadian championships, our trials, which were held in Ste. Foy, Quebec. At that time I was ranked number two in Canada, after Susan Auch, so I got a bye, and qualified to continue the World Cup season, and also to skate in the World Championships.

I found it terribly frustrating being injured. Here I was with this new faith, which gave me greater strength internally, and also somebody else on my side, and I couldn't understand it: "Why isn't something great happening to me?" But faith is something you develop over a lifetime, and this injury was making me realize that just because you become a Christian doesn't mean nothing goes wrong. You become a Christian, but that doesn't mean everything is

great, that all of a sudden your skating is great, and every relation-
ship is great. It doesn't mean you don't struggle in different ways.
That was my first lesson along those lines.

Looking back, I recognize that Lillehammer was a turning point.
The experience of falling in a crucial race made me question every-
thing, including my commitment to speed skating. Did I wish to go
on? After I became a Christian, I began to see that my athletic ability
was a gift I had been given. Once I stopped focusing on myself and
looked to God instead, a peacefulness came to me. Skating became
fun again. People ask me how can I be competitive, how can I be
aggressive and still be a Christian? And I respond that you are given
a gift, and you should use that gift to the best of your ability.

Becoming a Christian was a breakthrough in so many ways. It
made me more relaxed and confident, more at peace about skating,
because I know there's a deeper meaning behind everything. I've
learned not to put so much pressure on myself to achieve a certain
result. You do everything you can to prepare, you do the work and
the training, and then you don't worry about the result. Of course,
I'm not perfect at this. Far from it. But I realize there are things I
can't control, and I try to concentrate on the things I can change. To
me, that's a Christian attitude. Whatever happens, I come off the ice
saying, "Thank you, God, for the talents and opportunities You've
given me." And that makes me a more formidable skater. In a way,
no matter what happens, I can't be beat.

Looking back, it's like Lillehammer was an earthquake. People
are like houses, and my house got destroyed. For a while, I did not
know if I had the strength to rebuild. I wondered if I should turn
and walk away. Forget about speed skating, make another life. Many
athletes, and non-athletes, too, have responded to an earthquake by

September 23, 1995:
With my new husband,
Bart Doan,
on the very first
day of the rest
of our lives.

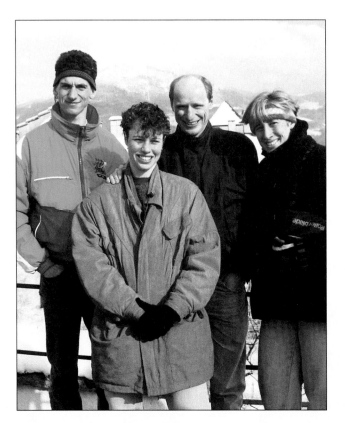

This could be Switzerland, could be Italy, I don't know. It's early 1990s. Between competitions, with fellow skaters Sean Ireland (later my coach), Pat Kelly, and Ingrid Liepa, I enjoyed a bit of sight-seeing.

Bart and I still talk about our Canadian Rockies honeymoon in Emerald Lake, Alberta. We can't help wondering where they got that name.

In 1993, with my friend Jody (Kaufman) Oliver and the rest of the Saskatchewan track team, I participated in the Canada Games in Kamloops, British Columbia.

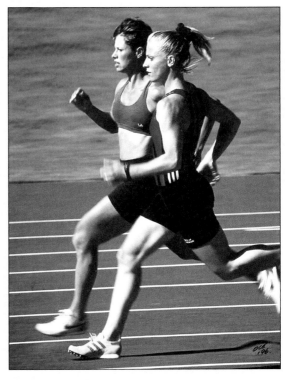

Jody (Kaufman) Oliver and I enjoyed track-training together. Still a good friend, Jody lives in Nokomis, Saskatchewan.

TO EVERYONE
AT VIKING,
Thanks for the
Fastest Skates
in the World!

Catriona
Le May Doan

Nagano '98
500m Gold
1000m Bronze
500m WR
37.55

Hallowe'en, 1998. With our niece, Emma, masquerading as a frog and our nephew, Ryan, disguised as a Teletubby, Bart and I prepare to do some heavy-duty trick-or-treating.

Opposite: At the Olympics in Nagano, Japan, in 1998, I skated the 500 metres in record time – 37.55 seconds. At that time I wore Viking skates, and I felt moved to thank the folks who made them – hence my writing on the photograph. In 2000, I switched to Van Horne skates, and now those are "the fastest skates in the world." (*Mike Ridewood*)

At a 1999 rodeo in Innisfail, Alberta, one hour north of Calgary, Bart wrestled this steer to the ground in 4.5 seconds – a decent time that left him just out of the "go-round money." (*Mike Copeman*)

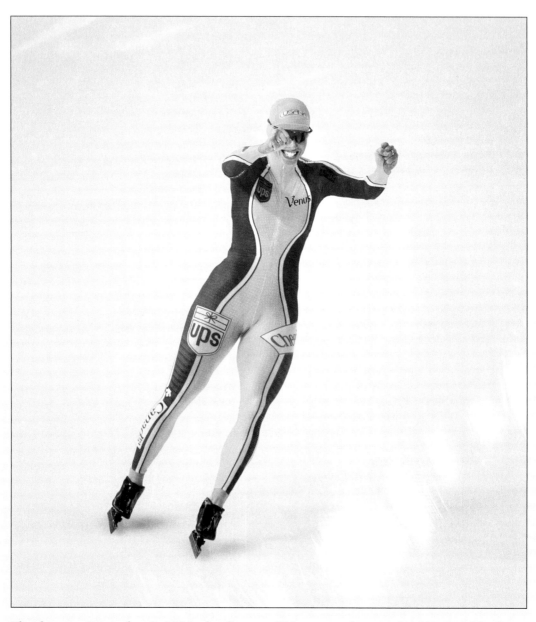

The date was December 9, 2001, the distance 500 metres, the time 37.22 seconds – a world record that stands today. It came in a World Cup race in Calgary. Here, I had just crossed the finish line and glanced at the clock. (*Todd Korol*)

Opposite top: After every race, I immediately talk to Bart and get his analysis. I don't know where exactly this photo was taken, but we're somewhere in Europe and I had skated reasonably well.

Opposite bottom: In January 2002, in Hamar, Norway, my friend and teammate Jeremy Wotherspoon and I celebrated our victories in the World Sprint Championships. This was the first time that skaters from a single country won both competitions, men's and women's.

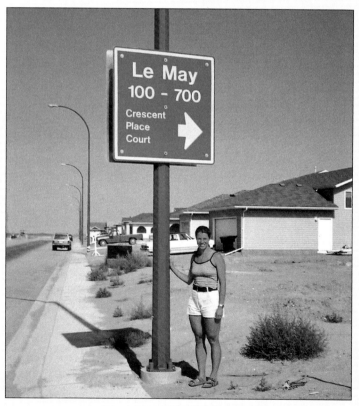

My horse, Threepar, spends most of his time in this community pasture in Gem, Alberta, a ninety-minute drive east of Calgary. In 1998, when this photo was taken, he was only two years old. Now he is bigger and smarter.

In the summer of 2000, during a first visit to "the Le May area" in Saskatoon, a man wearing a cowboy hat made me pose for this picture. I've got friends in that city who keep an eye out for hooligans.

doing that. But for me – no way! My parents taught me, mainly by example, that when the going gets tough, the tough work that much harder. My Christian faith provided me with a new foundation – a foundation far more solid than any I had before. But you lay a foundation, that's just a beginning.

Bart and I had talked about getting engaged. Together, we had gone to look at engagement rings. Bart knew that he couldn't go out alone and buy me a ring, because it had to be a ring I liked – a simple ring, classic. We had decided to buy through his uncle, who owns a jewellery store in Drumheller, ninety minutes east of Calgary. They call it the dinosaur capital of the world, because it's in the Alberta Badlands, where you find all kinds of fossils and bones.

If you're driving from Calgary to Saskatoon, you can travel through Drumheller. Late in 1994, having decided to visit my parents for Christmas, that's what we did. Bart said we had to give his uncle a down payment on the ring. We went into the store to look at the ring but his uncle said it wasn't ready. I was disappointed, but then, when we were back on the highway, I remembered leaving Bart and his uncle alone for a few minutes, and all through Christmas I was wondering if Bart and his uncle were telling the truth, and the engagement ring really wasn't ready. Because we knew we were going to get engaged, and the surprise element was, when was Bart going to give me the ring?

Over Christmas, Bart admitted nothing. Then my parents left on a holiday. We had enjoyed a hectic few days, so we decided to spend New Year's Eve watching the celebrations on TV. So we're watching and Bart says, "What's that on the tree?" And I looked, and Bart had hung the engagement ring on the Christmas tree. So, aha! Just as I suspected! The ring had been ready all along!

My parents phoned us the next day. They were surprised, because I hadn't prepared them at all. I know they thought I was quite young to be getting married – twenty-four – even though they themselves had been only slightly older when they had done it, Dad twenty-seven and Mum twenty-five. They didn't say anything negative, but I think they worried a bit, because they didn't know what would happen with my speed skating. I didn't have a university degree, and what would Bart and I do financially? Parents worry like that. One day, probably, Bart and I will do the same. Still, both my parents admire Bart, and they were happy because I was thrilled.

The funniest thing was that on New Year's Day, I phoned a really close girlfriend named Kim. And I said, "What are you doing in September?" Bart and I had talked about when we should get married, and I wanted September, because September is so beautiful in Saskatoon. You've got this river valley and all the trees along it, with their leaves changing colours, bright yellows and reds. So as much as I love the heat, and I do love it, especially the kind of heat you get in a place like Mexico, I also love autumn in Saskatoon, because you get warm days but cool evenings, and you put on wool sweaters and it's all so cosy. I didn't want a really long engagement, and nine months would be plenty of time to get organized. So I asked Kim, "What are you doing in September?" And she said, "Probably not much, why?" And I said, "Because I want you to be my maid of honour."

And she yelled, "Catriona! You've just ruined *my* surprise!"

Because the night before, she'd gotten engaged as well.

I ended up as maid of honour for Kim Polichuk, when she became Mrs. Kim Boehm. But first, on September 23, 1995, she served as

maid of honour for me, when I married Bart and became Catriona Le May Doan. And of course that was magical, with both our extended families there, and lots of friends who had made the drive from Calgary, and even a handful who were already there in Saskatoon.

Skating season was coming up, and that was the only problem with September: we didn't have a lot of time for a honeymoon. We decided to get out into the Rockies, which we both love, so we booked three nights at Emerald Lake Lodge. It's a two-hour drive west of Calgary, right near the border between Alberta and British Columbia. You drive up into the forested mountains to a parking lot, and somebody picks you up there in a rugged, all-terrain vehicle and takes you to the remote lodge.

We had a beautiful room overlooking the lake, which is a gorgeous aquamarine colour, truly magnificent. In the room we had no phone, no alarm clock. Our balcony overlooked the lake, and we had a fireplace that we kept going twenty-four hours a day, and they just kept bringing us firewood. Emerald Lake Lodge is famous for its food, so we ate too much. We rented a canoe and paddled around on the lake. And there was an outdoor hot tub, and outside was so cool, especially at night in the mountains, but it was wonderful to sit in that hot, bubbling water, looking up at the stars, so many stars, and it was so awe-inspiring. I remember thinking, Life doesn't get much better than this. Just then Bart said, "So how do you feel about the coming season?"

"The coming season? Bart, I feel ready – but do we have to talk about skating?"

11

❖❖❖❖❖

They say good things come in threes. I don't know if that's true, but first I discovered a faith that made sense of the world, and then I found and married my soul mate. If I were looking for number three, I would have to say: klap skates. I don't think that, as a "new" technology, they revolutionized speed skating, but they came close – and in ways that worked especially well for me. By the time the new skates arrived – and our team was not the first to adopt them – I was ready for them.

I had begun coming back in 1995–96, the skating season after I married. The previous year had brought the disaster at Lillehammer and then that frustrating foot injury. Worse, I wasn't having fun any more. But now, with a new faith and a husband behind me, I felt excited again – excited about racing, training, travelling, excited about everything. Starting in the autumn of 1995, I became a model of consistency. I finished the first four 500s of the year in 40.37, 40.48, 40.68, and 40.58. Analyzing my races, I saw that I was skating well for the first 300 metres and decided to work on the last 200 metres.

The previous March, on her thirty-first birthday, the American skater Bonnie Blair had retired. In February, skating in Calgary at the World Championships, she had set a world record for the 500 metres of 38.69 seconds – the fastest she would ever skate. In that same race, Susan Auch, my Canadian teammate and training partner, had won a silver while setting a Canadian mark of 38.94

seconds. At the time, I was still struggling with my foot injury, and I finished sixteenth.

During the summer, my foot healed. Early in December 1995, skating in the Netherlands, I finished second to Svetlana Zhurova in two races. The Russian skater had always started fast, but until recently, she had struggled with the corners. Now, having mastered the corners, Zhurova had become the woman to beat. The following February, skating again in Heerenveen, this time in the World Sprint Championships, I finished the first of two 500-metre races just three one-hundredths of a second behind Zhurova – about as close as it gets. I knew that, if I put together a perfect race, I could take her.

The following day, in her second 500-metre race, Zhurova fell. She skated three pairs before me, so when she went down, we knew the gold medal was there for the taking. One of my coaches, Jack Walters, told me to keep calm because the race was mine to win. I felt nervous and hesitant, because Zhurova's fall brought back bad memories. I couldn't help thinking: Stay on your feet, stay on your feet. All season long, ranked one and two, Zhurova and I had skated head to head. This was the first time I hadn't been paired with her, and at that I felt a slight twinge, because it would have been a great race.

The track was slow, but I focused and went for it – and became the only skater that day to break the 40-second mark, finishing in 39.64 seconds. The gold medal was mine – but also Canada's. I had become the first Canadian woman to win a speed-skating gold since 1977. That was when Sylvia Burka, skating at the World Championships, had won triple gold, taking the overall title and the two 1,000-metre

races. This time around, American skater Christine Witty took the overall title and I finished sixth.

Thrilled as I was to win the gold medal, I felt almost as excited about my increasing consistency. During the week I had been having stupid thoughts like, This is the World Championships. I have to skate well. Then I would think, Okay, it's just four races. I had gone back and forth all week, and beat myself up a couple of times, so the whole experience had been emotionally draining. I felt exhausted but also exhilarated, because now I'd proven it to myself: on any given day, I could outskate any woman in the world.

The following month, heading into a World Cup race, a reporter asked me to explain my new attitude and confidence. I mentioned reading the Bible with Bart, and said, "I enjoy what I do. If I didn't, I think I would quit. How could you do something you don't like? If I put the work in and I've done the best I can, and if it gets me to the podium at the Olympics, great. If it doesn't get me to the podium, that's great, too."

Speaking with another reporter, I suggested that even the fall at Lillehammer, which came when I had a shot at winning a medal, probably happened for a reason: "When I talk to kids, I bring in the fall at the Olympics. Seeing you at an international level and seeing you can have a bad day, seeing that anyone can have a bad day, that's a lesson worth learning. You don't just have success after success after success. You have setbacks, too."

Asked about drugs, I said, "It's easy to get wrapped up in the ugly things in sports, like drugs. If I stand on the podium at the Olympics, I'd like to think it's not going to change me. But you get athletes in it for the money, wanting to do well because they'll get something out of it. That's when you get people doing drugs. I don't want to do

well because of what I'll get out of it. I want to do well because I've put in the hard work."

That season, having won gold and silver medals at the World Sprint Championships, I became Canadian sprint champion. In World Cup competition, I finished with six silver medals – consistently placing second to Svetlana Zhurova, who over the years has become a good friend. By October 1996, newspapers were describing me as the leader of the Canadian women's speed-skating team. My best time at 1,500 metres was 2:07:19; at 1,000 metres, 1:20:46; and at 500 metres, 39.35 seconds. In the 500 metres, my best race, I still had two obvious targets – the Canadian record of 38.94, and the world record of 38.69.

To break the world record, I needed to shave seven-tenths of a second off my best time. This would be difficult but not impossible. In fact, with hard work, I felt I could do it. Bonnie Blair, who held that record, had peaked at thirty-one. On December 23, 1996, I turned twenty-six. Every year, barring injury, I skated faster. But, clearly, my fastest times lay ahead. I made it one of my main goals to chase down that world record and went to work with new intensity and commitment. I wanted that world record.

Then along came klap skates – the most important technological advance in decades. Klap skates had actually been around since the 1970s. The Dutch had perfected them by 1982, but they had never caught on. Then, in the spring of 1997, several Dutch skaters finished the World Cup season on klap skates and improved their best times significantly. Our coaches decided to take a closer look.

Klap skates work like cross-country skis. The blade is not fixed to the boot, but is connected to it by a spring-loaded hinge beneath the ball of the foot. The skate makes a clapping sound when the

spring snaps the blade to the heel – hence, the name. With klap skates, the blade stays flat on the ice a fraction longer than with traditional skates or "hardtails," as we call them. So, with each stride, the skater gets more of a push.

In June 1997, the Canadian team travelled to Milwaukee to do a training camp on klap skates. And I hated them. Oh, I really hated them. All I could think about was how much I hated them, and how I hoped they would be banned by the ISU, the International Skating Union. I had a tendency to dip forward while taking a corner, to shift my weight forward, and as soon as you get your weight forward on a klap skate, you roll forward, because it comes up at the heel. So it took me a while to adjust.

Then the coaches showed me a video from the previous season, when I had raced in Berlin. Sunlight streamed through the big windows there and reflected off splashes of ice, and you could see that I was leaving big holes. As you finish a push, your toe digs into the ice – but all those holes are wasted power. On klap skates, your toe doesn't dig in any more, because instead your heel comes up, and the blade stays on the ice. All of a sudden, instead of losing all my power into the ice, I was incorporating that power into my push. And that was a huge benefit.

Everybody skates differently. Some people skate using early pressure, which means that as they start the push, they apply pressure, and towards the end, they don't apply as much. For them, klap skates don't offer as much benefit, because they haven't been losing so much power into the ice. For skaters like me, who get a lot of power at the end of the push, klap skates are a great equalizer. I push, I push, I push, and then at the end of my push, I get lower and I push still more, and that's where my power is. With hardtails,

all that power goes into the ice. But with the klap skates, all of a sudden, it was going into driving me forward.

Once I got the hang of klap skates, look out! I started going faster.

Before long, I was so grateful that klap skates had *not* been banned. Most of the difference came in the push, but the new skates also encouraged me to improve my technique. With the hardtails, my shoulders would sway and there would be a ton of ice flying. As I got used to the difference, I became more efficient. And soon we began to see what this meant.

During the buildup to the World Cup season, on Saturday mornings, we do a series of training or tune-up races. They're timed, they fire a gun, you wear your skinsuit. You know these races don't count, but you get nervous anyway. You know that the result of every single race is going via the Internet over to Holland, where people monitor every result. And it's not just Canadians who are tuning up, either. Japanese, Russians, Americans – whoever is training at the Oval can participate.

By the first tune-up race, I felt pretty good on klap skates. And I went out and skated the 500 metres in 38.47. Of course, it didn't officially count, because it wasn't in a sanctioned race, but I had smashed Bonnie Blair's world record time (38.69) by more than two-tenths of a second. Everyone was stunned. And I thought, Is that real? I made them check the timing, to make sure nothing had gone wrong. They said, "No mistake. That was your time." That was when we knew things were going well.

Next day, in the 1,000 metres, I skated 1:17:29, breaking the world mark of 1:17:65 – a standard set almost ten years before, in 1988, by Christa Rothenburger of what was then East Germany.

These results came in a pre-season tune-up, when people expected a 500 metres of around 40 seconds, and a 1,000 around 1:21. To everybody's amazement, including my own, I had demolished two of the most sought-after world records. Officially, my times didn't count. Unofficially, they registered big time. In Canada, newspapers hailed my weekend results as spectacular. In Holland, Dutch newspapers trumpeted my arrival as a force. At the Nagano Olympics, mere months away, the woman to beat would be that Canadian skater, the one with the smile – Catriona Le May Doan.

12

After that weekend, and those results, a number of people asked me if I celebrated. Darn right I did. I went home, napped for two hours, then went out to a movie with Bart. More than ever, I was aware of the importance of my support team. Bart is far more than just my biggest emotional supporter and fan, obviously. He's the love of my life. But also he's very much part of my success. Nobody breaks world records without help. For me, Bart is number one – but he's not alone.

My family has been so crucially important – my sisters, their partners and children, my parents, Iain and Shona Le May. And their support goes all the way back. My parents never told me, "You have to do this." If they had done that, I would have stuck my heels

in. Instead, they allowed me to choose. But they said, "If you try something, you have to stick with it. You can't quit when it gets tough. You have to give it an honest effort."

And what about friends? They're not always standing there when I race, but they're there when I need them, and when I don't see them for so long, because of my crazy schedule, they don't get upset or angry. You know they're behind you, and that regardless of the result, they love you and care for you. That makes a huge difference.

I've written about the strength I gain from my faith in Christ. It might sound funny, but I know that God is a key member of my support team. Then there are the coaches and sports psychologists. During the buildup to any Olympics – I remember this particularly as we got ready for Nagano – the coaches talk about emotional preparation. They warn that, in the excitement of the Games, athletes sometimes forget why they're there, and what they went there to do.

Any Olympics brings distractions and surprises. Usually you're in a foreign country, a strange world, and getting oriented can be a challenge. You're dealing with a new language, a different culture, difficult travel arrangements. To avoid frustration in meeting loved ones, because you'll be off in the athlete's village, you need to plan ahead. Because of the crowds, you may have trouble finding personal space where you can sit and think. I remember one sports psychologist talking about "Blue Collar Preparation," by which he meant being ready to work through any challenge. Anger, guilt, fear, sadness – you've got to be able to manage your emotions.

One of my own challenges is to skate my best – to make that transition from training to racing. Another is to deal with the pressure I put on myself – my own expectations, as well as those of others.

That's tough. Psychologists also help with the team dynamics. That's maybe the hardest part of their job, because you're working with so many different personalities. People work in different ways, and you're trying to help them strive towards a common goal.

One of the best sports psychologists is Cal Botterill, whose daughter is on the Olympic team and whose son plays in the National Hockey League. Cal really helped me, and I think he helped Bart as well, because there's so much to deal with – the intensity, the distractions, the stresses, and the problems we all run into, not just in training but in life. Because those things affect our skating. Cal has gone back to Winnipeg, but Claire Wilson and Kimberley Amirault have taken over from him, and I find talking to them useful too – how do I deal with stresses? How do I make myself less nervous before a race? How do I stay less tense when I'm racing?

In 1997 and 1998, during the buildup to the Nagano Olympics, the national sprint coach was Derrick Auch, the older brother of Susan Auch. Before every race, he and I would do our routine. I'd skate over: "So, same thing? Long and powerful." And he'd say, "Same thing. Low and long." Until we exchanged those words, I wasn't ready to race.

People look at what happened and say, "Aha! The klap skates did it." To a degree, they're correct. I remember skater Sylvain Bouchard saying, "I don't know how we did without them." At a World Cup in Japan, the men drove the world record below 36 seconds, to 35.69.

Yet it wasn't just the klap skates, not for me. As I've tried to show, a number of things came together with a whoosh. I'd learned to focus on those things I could control and not those I couldn't. I'd worked on this before, but finding focus takes time. You've got to find a perspective, an attitude, an approach that works for you –

that allows you to make sense of the whole. And now, in the final six racing weeks of 1997, during the buildup to the Nagano Olympics, the great unfolding began.

On November 15 and 16, at the World Cup season opener in Roseville, Minnesota, I won three races and placed second in a fourth, incidentally winning my first World Cup race at 1,000 metres with a skate of 1:20.99. That was on an outdoor track, which is always slower. The weekend before, in a Can-Am in Calgary, I had astonished myself – not in the 500 metres, and not in the 1,000 metres, but in the 1,500 metres. In that race, I skated 1:57.87, smashing a world record (1:59.30) that had stood for eleven years. I remember having trouble with my pacing, and that in the last 20 metres, one leg gave out, so I leaned on the other and watched the clock.

The weekend after Roseville, back in Calgary, I discovered that suddenly, at 1,000 metres, I had become a contender when I beat the old world record with a time of 1:15.71. The American skater Chris Witty, always outstanding at the 1,000, took the gold medal. To do it, she had to set a world record, and she did: 1:15.43. Before this, I had never skated the 1,000 metres under 1:19. Now, I found myself contemplating 1:15 – and that required some adjustment. In fact, a whole new mindset.

In getting under 1:16, I had skated a great first 600 metres. That was the key to my time. In the final 300, my legs blew up. The lactate kicked in, and I got tight. I'd never blown up quite like that. I looked ahead to the finish line and hung on. But I quickly recovered. This was so exciting. The whole team was benefiting from these successes, gaining confidence, and everyone was skating well. Someone said to me, You're going to have to start thinking 37s and

1:15s, and those were times that, even the previous year, I would not have dreamed of doing.

In the 500 metres, when I had unofficially broken Bonnie Blair's record by skating 38.47, I told a reporter I thought I could skate a 38.3. So conservative! On November 22, in a World Cup race in Calgary, I skated 37.90 – and then, for good measure, I equalled that time the following day. I was thrilled that I had got under that 38-second barrier, long thought to be unbreakable. My next time out, I drove the record down still further, skating a 37.71.

Then, on December 28, at the Canadian championships in Calgary, I skated the 500 metres in 37.55, once again breaking my own world record. I hadn't really felt into the race, but had started on the inner lane and never looked back. I was thrilled when my time was announced as winning. In that race, Susan Auch placed second with a personal best of 38.20. As yet, no other woman had got under 38. Even now, five years later, only six or seven have done it. Somehow, late in 1997, I had shifted into overdrive and, not to put this too strongly, began pulling away from the field. Bart likes to say that I left the other girls in my dust.

A Dutch journalist pointed out that, on a single weekend – November 22 and 23 – I had broken world records in both the 500 metres and the 1,000 metres – something Bonnie Blair hadn't done in all her years of dominance. And also that, in erasing Blair's mark, I had slashed more time off a previous record than any skater since Tatyana Sidorova back in 1970 – the year I was born. Also that weekend, my three gold-medal races plus my silver gave me the most points ever taken by a sprinter in a World Cup.

By the end of December, I was ranked first in both the 500 metres and the 1,000 metres. I had broken world records at those

distances and also in the 1,500 metres – though the only mark that would prove untouchable by anyone but me, at least for a while, was the first, the 500 metres. I had become the first woman to break the 38-second barrier, and to this point had remained the only one. I was having a blast!

I didn't enjoy just the winning, but also the speed involved. To travel that fast unassisted, considerably faster than any sprinter on dry land, well, that was a rush. At first I felt embarrassed to admit it. But in the end, Bart convinced me that false modesty is basically dishonest. So when newspapers and magazines declared me, on the eve of the Nagano Olympics, the fastest woman on earth, I analyzed the numbers and had to agree. There was no getting around it. With the help of my support team, that's what I'd become – the fastest woman on the planet.

13

Next came the Nagano Olympics – those Games which, all skating season, we had been building towards. February 1998. No Canadian speed-skating team had ever been more ready. Everybody said, "It's the klap skates." But all the teams had taken to klap skates. We were one of the last teams to do so. For sure, the skates helped, but they helped everybody. I might have been more efficient on them. For sure, I had worked hard on technique and felt I was

skating better, technically, than ever before. People from other countries, and especially Holland, remarked on this. I could watch my video now and say, "That's pretty good skating." Whereas before, I would think, "Arrrgh."

Training had gone extremely well the previous summer, and we really did feel like a team. Then, when we started racing, and Jeremy Wotherspoon and I both skated unofficial world records, our coach, Derrick Auch, said that as a team we had realized, "Hey! We can skate this fast." Those amazing times gave the whole team a boost.

In January 1998, at the World Sprint Championships, I had become the first Canadian since Sylvia Burka to capture the overall title – the first in more than twenty years, since she had done it in 1977. I arrived at Nagano as the favourite to win gold at 500 metres, and a serious medal threat at 1,000 metres and 1,500 metres. I had skated in the Olympics before, at both Albertville and Lillehammer, but I'd never arrived as one of the women to beat. I felt strong and ready – good attitude, good perspective: the only pressure you feel is that you put on yourself.

At Nagano, for the first time at an Olympics, we would skate not one but two races at 500 metres. Because of the klap skates, everyone was skating faster. Statisticians, looking at race results, noticed that the best times almost always came when a skater started in the inner lane rather than the outer. The inner lane provides a whisker-thin advantage. To balance this out, we would race twice, as we did at the World Championships, with each skater starting once in each lane.

The first race, I don't remember clearly, which is never a good sign. But I skate all my races in pieces and the first 500 metres at

Nagano was no exception. Before I go to the line, when they're announcing the race, I run through a routine. To quiet my nerves and because I want icy control, I offer up a shorthand prayer, "Peace of God." I play with my rings, I adjust my glasses, I slap my legs. I think, "Stay low." Through all this, I am deadly serious, yet often I feel like I'm going to laugh. There's one for the psychologists.

When the gun goes, I spring out of the start, still thinking, "Stay low." As I hit the first corner, if I'm in the inner lane, I'm thinking again, "Stay low, stay low." If I'm in an outer lane, it's "Stay low, go deep." When you're in that outer lane, you've got to skate a wider radius so as not to hit the cups. This is counterintuitive, because you feel the other skater moving away from you and you want to go with her. So: "Go deep, stay low, go deep."

Heading into the backstretch, I zip past my coach, who stands at the side of the track holding up the lap-board with my opener on it, my time for the first 100 metres. It says 02, 03, or 04, meaning 10.2 or 10.3 or 10.4 seconds. And I hope it's not any higher than that. Entering the backstretch, I'm also thinking, "Patience," because you're looking at 100 metres, and you want to set up that straight-away. Meanwhile, coming out of the corner, you're still gaining speed, so you're thinking, "Patience, power, stay low."

Races can be won or lost at the second corner. Skating in either lane, you have to set up the corner – and you're travelling at high speeds. In the inner lane, if you enter the corner too narrowly, you'll hit the apex and shoot out. There's a tendency to hesitate, to pop up, and so I think, "Aggressive." Bart is standing just beyond this corner, and he might yell something like "Keep your hip in!" He knows my skating so well, and he can judge exactly how I'm doing.

If you're in the outer lane, again you have to think, "Go deep." Meaning, go deep into the corner, because the temptation is to cut too close to the cones. "Aggressive, hip in, go deep."

Coming out of that corner and starting into the home stretch, again you have to think, "Stay low." This is where I lose all my speed. Okay, maybe not all. My best races, flying down the home stretch, I'm thinking, "Stay low, power, patience." I can see the finish line, but if I skate towards that line, my shoulders get swinging. You can't afford shoulder movement because that will slow you down: "Stay low, power, patience."

That first 500 metres at Nagano, I won – but I won with a time of 38.39, more than eight-tenths of a second off my then-world record of 37.55. Eight-tenths of a second! And that wasn't the worst of it. The second-place finisher, Susan Auch, was only three one-hundredths of a second behind me, having skated 38.42. In third was Tomomi Okazaki of Japan, with a 38.55 – so she, too, was within striking distance.

These results upset me tremendously. To put it plainly, I was disappointed and furious with myself – just sick at heart. All season long, nobody had come within five-tenths of a second. And now I was ahead by only three one-hundredths! That meant anything could happen. Tomorrow, because Susan Auch was sitting in second place, she and I would skate head to head.

At that time, Susan was ranked number two in the world at 500 metres. She was a pure sprinter with a great start and a strong first 100 metres. In the 500 metres, I also started fast, but then, through the race, I could accelerate more. A couple of years previously, Susan had been ranked number one in Canada, and in World Cup races, she had vied for gold. Now, having come into my own, I was

ranked number one, both in Canada and the world. Inevitably, we shared a friendly rivalry.

So I was doubly furious with myself because I had let Susan get so close. She wanted to beat me and we both knew it. As well, this was an Olympics, where anything could happen. I couldn't help thinking of Lillehammer and how I had fallen. And so you think: I don't want to fall. I've got to stay on my feet. But you don't want to be thinking that because that's such a negative focus. Is that going to help you win? I don't think so.

What also upset me about myself was that, having arrived at the Olympics, where skating your best counts the most, I had failed to rise to the occasion. I had raced consistently all year, but now, at this big, big competition, I had gone stagnant. In fact, I had slid backward. Lillehammer was probably part of that – the fear of falling a second time. But a lot of people rise to these occasions and skate their best. And I try to deny it, to shake it off, whatever, but obviously I do feel the pressure, and the weight of expectations, even though most of that I bring on myself. My big fear now was that I couldn't rise to this occasion – that I would not skate well. I worried that, having arrived in Nagano as the hands-down favourite, I would fall apart in the biggest race of my career and blow my chance to win an Olympic medal. Okay, not just any medal, but a gold medal. Yes, I wanted the gold.

So you see the state I was in, and what a little Olympic pressure will do. Everybody has insecurities, but suddenly, mine were busting out all over. This is when you need your support team. I looked up and hey! There they were! My coach and the team psychologist, Derrick Auch and Cal Botterill. And there was Bart! And they were all saying the same thing, "Whoa, Catriona. Whoa." Sometimes

Bart, especially, makes like I'm a racehorse: "Whoa, now. Just settle down there."

"I won't settle down! And I'm not a racehorse!"

One way and another, they all said the same thing: "Catriona, we know you can do it." Maybe it sounds strange, but that made a difference. Because you don't know if you have the strength to actually do what you have to do – the mental strength, the emotional strength. And for me, that's the biggest thing. Because I'm competitive, but I'm inwardly competitive. When someone says, "Hey, let's race," I hate that. I really hate that. Because I don't enjoy that sort of competition. But get me out on the track and look out, because I want to beat everybody – but that's partly because I want to push myself.

Derrick and Cal and Bart talked me down. In a way, they challenged me. Okay, these other skaters were going to rise to the occasion. Why shouldn't I do the same? Why? I'll tell you why – because I think too much: "What did the other girls do? They did what? Oh, no! They're right behind me." And Bart is always telling me, "Don't worry about what the other girls are doing. Let them worry about you. They're watching you!" But here I was: "What if they skate fast? What if they skate a PB?"

"Who cares how fast they skate? You'll skate faster, Catriona. You'll skate faster, because as you've shown again and again, you're the fastest woman skater who ever lived."

These are the things they do. They help me turn it around. Come to think of it, why shouldn't I skate fast? I've skated fast all season. Why shouldn't I skate faster than anybody else? I've done it all season. Why not now? The next day, when I sprang off that start

line, you'd better believe I was skating to win. I was going for gold.

This race I remember. Susan is on the inside, and she has a faster first 100 metres than me. And the thing I am most proud of happens right there. I go into the first corner, which is a hard place to be when you're in the outer lane, because all of a sudden the person on the inside is moving away from you. She did the first 100 metres faster than I did – but I didn't panic. At that point, you could be going, "Help! Time to panic!" I came around into the backstretch and thought, "Okay, don't watch what she's doing. Just skate down the backstretch." As I skated the last inner, I thought, "If I stay on my feet, I know I can catch her because I have more speed." I came around that last corner and, still accelerating, I passed her.

It's funny the things you remember. At this point, I heard myself squeaking. When you're skating, if you put your foot down in the wrong spot, and then push, you squeak on the ice. And I was squeaking. That's something I don't do often. In training, even without squeaking, you get to recognize somebody's sound. If they're coming up behind you, you know – "Oh, there's Jeremy." "Oh, here comes Mike." And if Bart is around, and he's working on the ice, he'll look up because he can tell my sound. In that second race, I remember hearing my own squeaking, and thinking, "Uh, oh, I must not be skating that well."

I didn't skate a great race, but it was enough. Some of the girls got personal bests. With a 38.21, I was seven-tenths of a second off my own PB. Not so good. On the other hand, I had set an Olympic record and won a gold medal. Susan earned a silver by finishing three-tenths of a second behind me. I skated a victory lap, and that

was great because I could take my time and thank the people in the crowd for cheering me on.

I had talked with Bart about the possibility of my reaching the podium, and what that would feel like. We thought that when the Canadian anthem played, we would lose it. I did get emotional up there, but wasn't as teary-eyed as I expected, probably because I was still on such a high, and the adrenaline was still going.

Then in the 1,500 metres, though previously I had set a world record, I placed thirteenth. I was paying the price in exhaustion that all sprinters will pay in future, now that we skate not one race but two at 500 metres. Even so, I recovered enough to win a bronze medal in the 1,000 metres, and that was the icing on the cake.

With my own events finished, Bart and I went with some other Canadian skaters to watch the short-track competition. At one point, I went to buy a pop, and as I was returning to my seat, someone from the Canadian Olympic Association waved me over and said, "Can I talk to you for a moment?" Instantly, I thought, "Oh, my goodness, what have I done wrong?" It was like being in school and suddenly you're called to the principal's office. "Uh, oh, I'm in trouble." And you rack your brain. "What did I do? What did I do?"

But no, it was nothing like that. The assistant *chef de mission* wanted to know if I would carry the Maple Leaf for Team Canada at the closing ceremonies. I said, "Who, me?" She reminded me I had already won two individual medals at these Olympics. So why not? I've always thought that to carry the Canadian flag was a great honour, and of course I accepted.

At these particular closing ceremonies, all the flag-bearers went into the stadium together and then stood in the middle while the

teams walked by. To tell the truth, I was disappointed that I didn't get to walk in with my team. Still, it felt great standing there with the flag, and seeing everybody going by, taking pictures and waving, and I felt proud and humble all at once, because I was representing such a great team. To be singled out like that was a real honour.

Later, when the frost had cleared, we realized how well Canada had done. For those who insist on counting, Canadians had picked up more medals than ever before – fifteen at Nagano compared to thirteen at Lillehammer. We had collected more of them in ice sports than in snow sports, and we'd placed fifth overall, after Germany, Norway, Russia, and Austria – great northern countries, all.

Personally, I ended up having my best season yet. In the 500 metres, I finished the year as world sprint champion, world single-distance champion, World Cup champion, and Olympic champion. Also, I was the world-record holder, with my time of 37.55. In the 1,000 metres, I had finished second overall in the World Cup and won bronze at the World Single Distance Championships. I had won two individual Olympic medals, the only Canadian to do that at Nagano, and had also become the first Canadian female speed skater ever to do so.

All those accomplishments gave me great satisfaction. But flying home from Nagano, I found myself wondering, Is that what it's all about? Winning championships and setting world records? The Olympics were sinking in. Three weeks before, on the flight to Japan, I had thought, "Okay, in three weeks, I'm going to fly home and I'll know how it went." For a second, you want to be able to look into the future and see how it will unfold. On the flight home, I felt I wanted to reach out to that slightly earlier self and say, "Hey, I'm here

in the future and it's great. You're coming home with two medals!"

Walking through the Toronto airport, I heard somebody say, "Look! There goes an Olympic gold medallist." And I thought, "Hey, that sounds neat."

Shortly after that, while interviewing me about the Olympics, a reporter chuckled, "So, Catriona. Is this when it happens? Is this when you change?"

"No chance," I told him. "I'm still the same person. Just me."

Later still, when I was catching a flight home to Calgary, a bunch of people stopped me: "Hey! You're Catriona Le May Doan! Congratulations! And thank you! You've made Canada proud."

That's when the feelings well up inside me, when moments like that happen. They remind me why I do this, and what my skating is really all about. I don't think I'll ever get tired of people telling me that I've made Canada proud.

IV

THE SECOND CORNER

14

❖❖❖❖❖

Bart and I had decided that, after the Nagano Olympics, we would take a short holiday. Nothing fancy or too extravagant – just take a couple of weeks after finishing the World Cup season and go to Scotland, where I had visited so often as a girl, and where I had never yet taken Bart. But then, because I had won two medals, reporters wanted to talk to me. Lots of media attention. People told me, Uh, Catriona, maybe you shouldn't go away right now. Maybe you should stick around and work on getting your image out there into the public. A strike-while-the-iron-is-hot attitude.

But Bart and I had put in a hard year. The Olympics had been stressful, and we needed to get away, just the two of us. Probably it would have been smarter to stick around, but for us, the holiday was mandatory. So we went for two weeks and stayed in Tayvallich, that little town northwest of Glasgow. We stayed in my dad's chalet, that tiny A-frame, and visited my relatives. It was perfect – so relaxing,

and we really enjoyed that slow pace. I hadn't realized how tired I was, not just physically but mentally and emotionally.

After we got home to Canada, because I was still worn down, I spent a month hanging out – no training, just resting. I played golf. I went horseback riding. I ended up taking six weeks off. And the most bizarre thing happened – I grew taller. That's right! At age twenty-seven! Our coaches and doctors take precise measurements, and I grew more than half a centimetre, from 170.7 to 171.4. At the same time, my feet grew half a size, so from a size nine, I changed to wearing a nine and a half. That's how I found out. Suddenly, my cycling shoes were too tight. And then my golf shoes, same thing. What's going on?

I went to the team physiologist, Dr. Dave Smith. Are my shoes getting smaller? I'll take any drug test you want to give me, and pass with flying colours, so this is really strange. The doctor explained that I had never before taken a long break after a skating season. I had always gone into track, or else into dryland training, and I had never let my body recover. I had never rested properly, so I had all this pent-up growth. I thought, Great! Those other skaters had better watch out, because next season, when I get back on the ice, I'm going to be bigger and stronger than ever.

Funnily enough, my coach, Sean Ireland, was thinking the same thing.

For years, Sean and I had skated together as teammates. I had not had any problem putting him in an authority position, though, because he knows so much technically. Also, he works so well with Dr. Smith. And they're the ones who sit down together and say, Okay, this is where we want to be at this point. How are we going to get there?

Before this, we'd had outstanding coaches like Derrick Auch, who had left to become a lawyer. But we were frequently changing coaches so it was hard to plan ahead. After Nagano, Sean Ireland and Dr. Smith looked into the future. They said, We want our skaters to peak in Salt Lake City. How can we make that happen? Together, they designed our four-year program. The idea was that we would concentrate on building volume for two years – more weights, more laps, more biking – and then focus on building speed with a view to peaking in February 2002. The last two years would involve more refining, more technique, because by then we would have a greater physical base.

In the middle season, however, 1999–2000, I ended up pushing too hard. I could never recover. I felt my energy wane, and that was scary. It wasn't just that my legs got tired, but I felt mentally drained. We were training six hours a day. And training hard. I guess it's like doing any really tough job. I would go home and fall into bed. That's how tired I was. Completely exhausted.

We knew that, long term, we would benefit, because we were expanding the foundation. They warned us: You won't be as quick off the start. And we weren't – because we were building, not sharpening, not honing. Where before everything was speed, now there was so much volume. I'd never trained so hard. But I trusted the coaches, and I trusted the program.

We skaters compared notes and we all agreed that the strategy was amazing. On paper, at least, Sean and Dave had planned the program to the day. We skaters would peak not in December 2001, and not in January 2002, but in February 2002, during the Olympics – and in mid-February at that, on the days we were going to race. And the skaters could see that. Even the specifics looked

impressive. All we had to do was execute, just follow through. What could be hard about that?

Whenever we were focusing on technique, Sean would have a video camera out there. You don't want that too close to a race, and especially not just before the biggest competitions of the year, because at that point you don't want to analyze too much. You want to skate your race naturally. But sometimes it's good to watch yourself, because you see something and you go, "Oh, yeah, right."

The camera is great for working on your start. You get to break it down step by step. Other times, we'll have a session devoted specifically to video. Sean will break us into groups, and one group will skate intervals while the other analyzes videos. After a race, sometimes we'll watch a video. I don't spend enough time doing that. I'll think, "Okay, I have to watch that race, because that one felt good, or because in the first corner, something went wrong." But the following weekend, I'm lacing on my skates and I realize, "Uh oh, I didn't watch that last race!"

One thing you notice when you watch video is how differently people skate. More than one person has exclaimed, "Hey, you skate like a guy." To me, that's a good thing – as long as they mean I skate like Jeremy Wotherspoon or Mike Ireland. Because I look at them and think, That's how I want to skate. Jeremy's so powerful, so strong – plus he skates so well technically. Mike also skates extremely well. And yet the two of them skate so differently. They have completely different styles – how low they stay, how they stride, how they push.

Take a look at two people walking. They both put one foot in front of the other and propel themselves forward. Yet they differ in so many ways. Every one of us on the team can watch a video and know at a glance if it's Mike or Jeremy or me or one of the others,

just from the way we hold our hands, the way we push, the way we swing our arms. We're all unique in the way we skate.

Our coach, Sean Ireland, is not just a great planner. He's also very good with equipment. Skaters have always paid careful attention to their skates. But after klap skates came along, and we saw the difference they made, some of us became almost obsessive. For sure, we're all precise about the "rocker" and the "bend" of our skates. The "rocker" is how round or flat the blade is along the bottom. Hockey skates are much rounder than speed skates, which are relatively flat. The "bend" is the way the blade angles, the slant at which it cuts the ice. You can run a device along the blade to measure both the rocker and the bend.

We sharpen our skates by hand, sometimes every day, and Sean checks them every six or eight weeks – and always before big competitions. He's got a knack and a very good eye, much better than mine. He knows what rocker works for me, and what the bend should be, and he takes care of it better than I could. This gives him too much work, of course, because everybody badgers him to do their skates.

What's amazing, looking back, is how exactly the results of races and competitions reflected the workings of the four-year program. During the first two years after Nagano, I won most of my 500-metre races, but I never threatened my own world record. I was stronger than before, and more fit, but I had lost a little on the start, no question.

During the first year of the program, in December 1998, I was voted Canadian female athlete of the year. Sports editors and broadcasters awarded me 100 of 163 first-place votes, and total points of 399, compared with 249 for the second-place finisher. But this I

owed to the preceding season, when I had won seven gold medals and one silver in World Cup 500-metre races. At the World Sprint Championship, I had taken the overall title by winning gold in the 500 metres and bronze in 1,000 metres. Then, at the Nagano Olympics, I had won gold and bronze.

As I told a sympathetic audience in Toronto, confidence has always been my weak point. The training might go well, but the hard part was making it happen at an international meet. I said then, and I still believe, that speed skating is something like golf. If you try to hit the ball really hard, to kill it, you're not going to hit it far. I have my best races when I relax and slip into this state where I'm strangely aware of everything around me – aware of people in the warm-up lane, aware of people on the mats. I relax so much that everything just flows.

In February 1999, after struggling through the World Cup, I clocked the fastest 500 metres of the season – a 37.89 at the World Sprint Championships. This was considerably slower than my world record of 37.55. Still, I remained the only woman ever to skate the distance under 38 seconds. Svetlana Zhurova placed second with 38.27 – though she sliced open her left ankle with her blade and required six stitches. In the 1,000 metres, I skated my best time of the year (1:15.57), but Monique Garbrecht of Germany won gold with a world record 1:14.61. As a result, she edged me out for the overall championship by .035 points.

Afterward, Bart caught me beating up on myself. He said, "Look, if you search for an area where you could have improved that fraction of a second, Monique could do the same. There's no sense in it." He told me to be happy that I'd skated four good races that weekend and to build on that. He was right. You had to hand it to

Monique that day. She hadn't finished higher than fourth in the World Sprint Championships since 1991, and when she saw her record time, she burst into tears.

Through an interpreter, she told a reporter: "It's been a long road back. This one means much more than 1991. I would never expect a world record, but Catriona is so good at the 500 metres, it really helps to skate against her. After the first lap, I just wanted to stay close to her, and when I achieved that, I was skating well enough to finish strong. I knew the last race would be the most important for me."

In March 1999, skating in Heerenveen, Netherlands, I won gold in the World Single-Distance Championships. I was still doing that more often than not. But by the standards of 1997–98, I was struggling. I don't know why this surprised me. The coaches had told me, "Look, this is a four-year program. You're going to lose something on the start." Those first couple of seasons proved them correct. I didn't come close to threatening my own record in the 500 metres.

The coaches told me, "Catriona, be patient." I did find it hard to be slower than I had been. Yet I was taken aback at the World Sprint Championships when a European journalist asked, "Is it necessary for you to win?" I thought a moment, then said, "The necessity part takes away from the wanting part. I don't ever want it to be a necessity thing, or a have-to thing, but a want-to thing. You hope everybody has four good races. Because if somebody beats you, you hope it's because they were faster, not because you had a poor race. That's what makes it exciting and challenging."

Not until early 2001 did I regain my earlier form. This was in year three of the four-year program – and, according to the coaches,

right on schedule. In January, I skated a World Cup 500 metres in 37.40 – and so, after three years of building, I broke my own world record. Of course, you wonder: was that a one-shot deal? But then, on March 4, I won another race with a 37.42. That one was historic, because for the first time, three women skaters cracked the 38-second barrier in a single race: Svetlana Zhurova skated a 37.59, and Sabine Volker of Germany a 37.95. Now, counting myself and Monique Garbrecht-Enfeldt (she had married), four women had broken that barrier.

Apparently, as we headed towards the Salt Lake Olympics, the other leading women sprinters had decided they weren't going to roll over – and that was fine with me. In fact, that was the way I liked it. I still had a lead of almost two-tenths of a second over my nearest competitor, and I'd begun to believe I could skate the 500 metres in 37.3.

In the 1,000 metres, meanwhile, I had also started to click. On March 3, I shared top spot in a World Cup race with American Chris Witty, both of us finishing in 1:15.01. This was better than I'd expected – though when I said that publicly, I joked that it might not be the best thing to say, and that probably our sports psychologist would want to talk with me. We had gone three weeks without racing, and so it had become difficult to gauge where anybody stood.

Previously, I had been struggling with the 1,000 metres. Now, suddenly, while skating against Chris Witty, I had registered the fastest 600 metres of my career. I'd won by going strong at the beginning and then maintaining my speed. I'd seen the board and knew my lap time, and for much of the race I was beating my best time ever of 1:14.99. Entering the final corner, I thought I might break the world record, but in the last 200 metres, I ran out of

steam. Two days later, although I placed fourth, Chris Witty cred-
ited me with helping her set a new world record in the 1,000 metres
of 1:14.58: "I knew if I stayed with Catriona, then I would have a
chance to get the record, especially on the last lap and on the back-
stretch, because I would have somebody to chase."

Still, the season was not done. I had wondered aloud whether, in
the 500 metres, I could crack the 37.30 mark. On March 10, 2001,
skating at the Oval in Salt Lake City, I did it. I felt good. I started fast.
And I ended up skating 500 metres in 37.29 seconds – a new world
record. The four-year program was working. The Olympics lay one
year ahead. All I could think was: 37.29? Let the Games begin!

15

❖❖❖❖❖

In September, we got back on the ice. It was my first month of full-
time, on-ice training. My program usually consisted of a skating
session in the morning, and then either weights or a bike ride in the
afternoon. My one day off, Sunday, went by far too quickly, but I
knew I would see the benefits of my hard work at the Olympics.
After all, this was the final year of the four-year program.

I have already mentioned the impact of September 11. The hor-
rible events of that day affected people around the world, and we
skaters were no exception. Instead of acclimatizing to Salt Lake, as
planned, we sprinters continued to train at home. Early in October,

the skating team travelled to Santa Barbara, California, to do a dryland training camp. We filled eight days with biking, running, and calisthenics, and even played some beach volleyball. It was nice to take a break from ice training and bask in the warmer weather. The most important benefit of being away from home, though, was that we began coming together as a team.

We returned home feeling refreshed and ready to get back on the ice. To compensate for the sea-level training when we were in Santa Barbara, and because Salt Lake City is at a high altitude, we slept a couple of nights in altitude tents. Then we had three days recovery time, so Bart and I made a quick trip to San Diego, where we visited friends and hung out on the beach. We knew this would be our last break before the season began.

On October 21, I skated my first tune-up race of the year. Sean Ireland and I had settled on 1,500 metres as a good way to begin the season. Usually, you feel less pressure skating a distance in which you don't often compete. But I felt so nervous it was ridiculous. I've been skating twenty years, and the butterflies were whirling so wildly, I thought I would be sick.

Still, I skated well. Compared with early the previous season, I had improved by a second and a half – surely a good sign. The following weekend we raced both the 500 metres and the 1,000 metres. Seeing the Oval set up in race mode always gets the adrenaline pumping. You see the cups lining the track and the electronic timer ticking away, and then you put on your racing skinsuit – to me, that means business.

I shouldn't get nervous. These are just training races. But I get worked up anyway. Usually, I skate over to Bart. I can always tell Bart how I am feeling, and just talking with him makes a difference.

You need that in order to be the best that you can be – to have someone with whom you can share your emotions. Bart knows I put pressure on myself. But he puts things in perspective. He reminds me that this is just training, and that I should focus on the technical aspects of my race, those things I want to work on, and not worry about my time. He reminds me that the season is a process. We are into heavy training now, and the idea is to peak in February at the Olympics.

My main goal that weekend was to stay low, and that I accomplished for most of both races. The exciting thing was that, even though I didn't skate my best, the times were fast – very fast. In the 500 metres, I skated my fastest-ever first training race. I could feel that the power and the strength were there, and that excited me. I couldn't wait to start the World Cup season.

Then, after a single day of rest, came another week of hard training. Towards the end, I felt so drained that all I could do was stumble around on the ice, tripping and falling. Three times I tried to start the intervals I was supposed to skate, but my body would not listen to my brain. This was so frustrating, but it made me I realize how exhausted I felt. You can push your body only so far before it cries, "Enough!" Once again, not only was I drained physically, but also mentally and emotionally. I knew that to peak in February, I would probably have to hit bottom in October, but it's hard and scary to feel so tired. Sean Ireland gave me two days off to recuperate, and they couldn't have come at a better time.

The next few weeks felt almost like the World Cup. That's because the Big-O in Calgary is one of the best covered ovals in the world, and foreign skaters began arriving to train – also, to get used to the fast ice. In November, Sean set up an experiment for me and some of the men.

He organized a series of races the way we would skate them at the Salt Lake Olympics. First, we skated two 500-metre races twenty-four hours apart. Then we waited two days and skated the 1,000 metres. We went through this entire cycle and figured out what workouts to do between events. The exercise also helped us focus and made us comfortable with the sequence of events.

After that, we concentrated on fine-tuning. Speed skating can be frustrating, because tiny changes in technique can make a difference, over 500 metres or 1,000 metres, of several hundredths or even tenths of a second. And that's the difference between standing on the podium and watching the medal ceremonies from the sidelines.

Now, after talking with the coaches, I focused on being patient. By slowing down my push and not rushing my stride, I could use more of the power and strength I had developed over the past four years. Of course, it is hard when you're trying to slow things down and everything inside you is yelling, "Go fast! Go fast!" But in November, in my final training race before the World Cup season, I skated one of my fastest 500-metre races ever, finishing in 37.39 – just one-tenth of a second off the world record I had skated the previous March.

On November 27, the skating team flew to Utah for the first World Cup meet of the season. Salt Lake City is 300 metres higher than Calgary, and you feel the difference when you do things like skate or climb stairs. We spent a couple of days adapting to the altitude change. We were surprised to see that the venue wasn't yet "Games ready," and that there was still so much construction happening. But this was where I'd skated my world record 37.29, and the ice felt faster than ever.

As usual at a World Cup, we would race twice each day. On Saturday, we would skate both a 500 metres and a 1,000 metres, and on Sunday we would do the same. But first, on Friday night, the coaches met and drew names to determine which pairs would skate together. Those with the fastest personal bests would be "seeded" or grouped together, and they would skate last.

On Saturday, even though during training I had worked out some of the butterflies, I felt quite nervous. Being the first World Cup of the season, everybody wanted to see how we measured up. I skated a decent 500-metre race that was good enough for gold. It included my fastest-ever 100 metres, but I had tightened up for the rest of the race. I was pleased to show everyone, including myself, that I was skating well and on track for a big year. But mainly, I thought, "Whew! I am glad that's over!" I felt comfortable, settled into a groove, and skated well enough in the 1,000 metres to finish fourth – and just two-tenths of a second off the podium.

Sunday was almost a carbon copy of Saturday. In the 500 metres, I skated slightly faster, clocking a 37.30 – just one-hundredth of a second off my world-record time. I felt a twinge of disappointment, but Bart said, "Hey, Catriona! You have to leave something for February." My 1,000 metres was a couple of tenths slower than Saturday and I finished fifth. By the end of the weekend, I felt quite tired, as this was the first time that we skated four races that year.

Overall, Canadians enjoyed a great World Cup opener. We won six of the eight races, counting both men and women, and in the men's 1,000 metres, Jeremy Wotherspoon set a world record. We packed our skates and headed home, satisfied that we had showed the world that, come time to skate at the Salt Lake Olympics, Canada would be the team to beat.

The next weekend, we had another World Cup meet. This one was in Calgary, on our home ice. When I'm getting ready to race, I try not to think about world records. But all week, people had been talking, speculating. For a couple of years, I had remained the only woman to skate the 500 metres under 38 seconds. I had broken my own world record seven times, driving it down and down: 37.55, 37.40, 37.29.

In Salt Lake, I had just skated 37.30 – a whisker off the record. Now, skating again in Calgary, and with all the talk, I couldn't help thinking, Wouldn't it be neat to set a record at my home track? A lot of média people focused on this: How many records will go? Can you break your world record *again*?

I believe that if you're thinking of the end result before you start, you're thinking too far ahead – even if it's just 37 seconds ahead. I still used my old method – try to break the race down, and skate it piece by piece. And the day of the first 500 metres, I thought, Okay, I'll go and skate the race piece by piece, and do the parts that I know how to do. So on the first day, the Saturday, when I finished racing and saw the time, and it was 37.29, I was really happy, because officially, it counted as a record. That drew Calgary even with Salt Lake City and you couldn't say Salt Lake was faster, because the two Ovals were even.

But that night, I lay in bed thinking, Gee, if I can go just one-hundredth of a second faster, gain a little bit here and there . . . no, stop it, that's a good time, be happy. But then I would remember reporters asking, "Can you do it tomorrow?" On any given day you can do it or not do it, I should have said, and now I've got to stop thinking about it.

Obviously, I wanted to set a new record – not just for myself, but to bring it back to Calgary. I remember the race vividly, because when I have a good race, I see and hear everything around me, everything happening at once, so that I'm far more aware than usual. Years before, I had asked our sports psychologist if this was strange, because you hear people talk about going into "the zone," where they say they're so focused, they have blinders on. When I have a great race, I'm the opposite. I can hear the announcer, and I can see who's on the mats, and I can even make out every word they say. I think it's because I get so relaxed. It's not something I do but something that happens, and then I don't rush my push, and I use all my power.

I don't recall now if it was that week or the week before, but I remember Neal Marshall saying something to me. Neal used to skate, and was a great skater, and since Salt Lake he has been appointed to assist Sean with sprinters like myself. Back then, he was coaching the up-and-comers, and he said, "You know, Catriona, maybe this isn't something you need to hear at your level, but there are a couple of things I tell my younger skaters."

Now, I talk often with my coach, Sean Ireland, just as I used to talk with Derrick Auch, and we analyze every race. But sometimes when somebody from outside the inner circle throws something at you – it's not anything different, necessarily, but sometimes just a word here or there – you'll think, Okay, that makes sense. So when Neal said, "You're at a different level, and maybe you don't need to hear this," I said, "Forget that. We're all doing the same thing."

Neal continued: "When you get to the backstretch, remember: your first two strides will set up your straightaway. At that point, just think patience. Try almost to slow it down."

I knew, of course, that I had to set up my straightaway. But usually I just let it happen, and coming out of the corner, I don't think about anything. Neal reminded me, Right: you have to set up the straightaway. That's 100 metres you have to set up. And on the Sunday, I came out of the corner in the second 500-metre race, thinking, Okay, set it up with your first two strides. At my last corner, coming out of the straightaway, I thought of that again, and with about 50 metres to go, I started to get excited, because I had seen the time for the first 100 metres, and I felt good, and I thought, Maybe this will be a record.

When I do things like that, when I start thinking about records, I don't like the way I skate. I've seen the video, and I don't like how I skated those last 50 metres, so I truly believe I could have gone faster. But when I crossed the finish line and saw the time, 37.22, a world record, I thought, Hallelujah! And part of that joy was that we brought the record back to Calgary! Because now, in North America, we have two really fast tracks, making for some competition, a bit of rivalry between Canada and the United States – which is a good thing, because it makes us all faster.

Bart was happy, too, and in a funny way I was happy for him, because the previous two weeks, he had been doing a lot of work on the ice. I had seen him and the other guys go into the Oval at 11 p.m. and work on the ice until three in the morning. And then do it again the following night. Skaters are finicky about ice. We complain about it and say the ice feels too sticky or too slippery, and nobody else can feel the difference. But then I see these Zamboni guys working on that ice until three in the morning, and I realize they really do want the ice to be fast. They take pride in it.

We took a break from racing over Christmas. In the New Year, we went to Heerenveen, Holland, for the first World Cup meet of 2002. The fans were so crazy and excited – all 10,000 of them. This was a pre-Olympic competition, so they were even wilder than usual. The energy in the building was amazing. I didn't break any records but I skated well, especially in the 500 metres. I won both races and was especially happy with how I skated technically. The 1,000 metres was not so wonderful. I started well, but felt tired after 200 metres. It's not a good sign when you tire after skating half a lap and still have two laps to go. Most of the Canadian sprinters were feeling the same way. We realized it was a combination of jet lag and overwork from a hard last block of training.

Still, we found Heerenveen exciting because it was a combined sprint and all-round World Cup. That meant our whole team was there skating all the distances – the first combined meet of the season. It was great to get together and see some awesome results. Witnessing the podium finishes for our team was a real motivator for the World Championships the following weekend.

On February 15, we travelled to Hamar, Norway. I hadn't skated there since 1997 and found it exciting to be back. Bart hadn't visited since the Lillehammer Games eight years before – the Games that had brought us to marriage. The beautiful Oval in Hamar is called the Vikingship. On the inside it looks like an upside-down Viking ship, and it's all made of wood. It's a spectacular facility.

As the weekend approached, you could feel the energy building. World Championships are second to an Olympics, but they're still a very important competition for all of us. Just before the weekend started, I had that telephone call, when Sally Rehorick, our *chef de*

mission, asked me if I would be willing to carry the Canadian flag at the opening ceremonies in Salt Lake City. The official announcement was planned for the Friday evening before our Saturday competition.

We had to travel twenty minutes to the next town that was capable of a live satellite feed, so that I could be in touch with Canadians back home as the team was introduced and the flag-bearer named. This was not part of my usual, pre-race routine, but it felt great in so many ways. I was so excited to be a part of the celebration, and the event took my mind off the upcoming races and kept me from my usual fretting.

Next day, we started skating – and the weekend was perfect! The sprint championships depend on the results of four races – two at 500 metres and two at 1,000 metres. I ended up winning both 500s, setting a track record of 38.05 on Saturday and skating a 38.10 on Sunday. I felt both races were good – not perfect, but good, and I was even happier with the two longer races, in which I placed third on Saturday and second on Sunday. That last 1,000-metre race was one of the gutsiest I ever skated. And when someone added the totals, I had done something I hadn't done since just before the Nagano Olympics in 1998: I had become world sprint champion.

The icing on the cake was that Jeremy Wotherspoon won the men's title. Apparently, this was the first time that a man and a woman from the same country had won sprint championships in the same year. Sean Ireland had four skaters on the podium – three men and one woman. And when I looked ahead to the Salt Lake City Olympics? I thought, "Here come the Canadians!"

16

❖❖❖❖❖

By the time we left for Salt Lake, the media were describing me as the closest thing Canada had to a certain gold medal. One article quoted Dan Jansen, the gold-medallist American skater, "If a gambler came up to me and told me he was going to bet every penny he had on just one speed skater to win gold, and he needed me to give him the best bet, it wouldn't take me long to give him his answer. Catriona Le May Doan. Since the retirement of Bonnie Blair, no skater, male or female, has dominated a single distance like Le May Doan has ruled the ladies' 500."

Okay, our four-year program was paying off. So far this year, I had set a world record in the 500 metres and become world sprint champion. Just before the Nagano Olympics, I had enjoyed similar success, and then I'd won two medals – a gold in the 500 metres and a bronze in the 1,000 metres. Naturally, I wanted to repeat. The media kept reminding me that, in the 500 metres, I had not been beaten all season. At that distance, I had won fifteen of my last sixteen races, finishing second only on an outdoor track in Finland, where conditions had been wild.

People forget that my success is driven by self-doubt. That I'm weak in self-confidence. I'll look at the other girls and think how well they're skating. Oh, that looked good! Right away, Bart will say, "Don't look at them. They're looking at you! They're chasing you!" And it's true, I suppose, but I have to be reminded. Sure, I want to walk around with an air of confidence. But if ever I looked arrogant or cocky, I would really hate that.

In Salt Lake City, as I've admitted, the Olympics began badly. The whole Canadian team was down. Someone asked Jean-Luc Brassard, the great freestyle skier, how it felt to finish out of the medals. Back in 1994, at the Lillehammer Games, Brassard had been Canada's gold-medal king. At Nagano, he had lost some lustre. Here in Salt Lake, he had been hoping to make a comeback. It hadn't happened. He was disappointed. He said, "It's like taking a baseball bat in the face."

In other words, down you go. And no, you don't get up.

A lot of Canadians were asking, Is this the moment? Is this how we are going to remember the Salt Lake City Olympics? As the Games where we took a baseball bat in the face? And I was thinking, No, it's not – not if I have anything to say about it. Sure, as a team we had taken a couple of shots. But our spectator sport is hockey, not baseball. We had taken punches, not blows with a bat. We had to pull ourselves together and show the world, hey! we're Canadians. We can take a punch and come back.

Of course, even without bad news, I manage to put pressure on myself. That's one thing I don't have to work at it. Logically, I understood that if I skated two good races, nothing special, I would stand on the podium and possibly at the top. Because of how I'd been racing. You hate to sound arrogant, but the numbers were there. Bart always says it's okay to be confident. And I felt because of how I'd been racing, and how I was capable of racing, I could take the gold.

But then you see Jamie and David robbed. And you see Jeremy fall – the world sprint champion! And maybe you remember falling yourself, eight years before, at the Lillehammer Olympics. You tell yourself, Okay, you're not facing a panel of possibly crooked judges, you're racing against the clock. If you stay on your feet,

nobody can take away your result. Still, you know you can fall. You do remember Lillehammer. You know this is an Olympics, and that anything can happen.

Finally, the day arrived – February 13, 2002. The women's first 500 metres was scheduled for five o'clock in the afternoon. That didn't help. All I could think about was the upcoming race. Why was it scheduled so late? Eventually, the time came and I felt ready, I felt good. Of course, I was nervous – maybe a bit more than usual. Okay, I was a lot more nervous than usual.

The race itself remains a blur, which tells me how tense I was. I remember standing at the start and seeing a flash go off. The announcer had kept repeating, every minute or so: "Please, no flash photography." So we were on the line, and then at ready, and there's a short pause before the gun goes. And I saw a flash and moved. So I stood up and pointed at the crowd, because I didn't want to be called for a false start. I wanted the starter to know that I went because there was a flash. But he saw it, too, and he said there was no false start, because there'd been a flash. And again the announcer said, "Please, no flash photography."

But you have to regroup. I was on the outer, where you can see a bit more of the crowd. And I remember going into ready again, and the professional photographers were standing not far from us. Probably they were ten feet away, along the mats. When we went into ready, I felt frustrated, because I could hear the shutters going, and even if it's not a flash, it's distracting. Then, bam!

As I say, I don't remember the race. I do remember looking up and seeing my time: 37.30. Okay, I was just eight one-hundredths off my world record. And with that time, I had set a Olympic record. Also, I was leading the race. All that was true. Still, I felt

terribly upset. The trouble was that Monique Garbrecht-Enfeldt, the great German skater, had just done a personal best and skated a 37.34. I was leading, all right – but only by four one-hundredths of a second.

This was just like Nagano! There, after the first 500 metres, I had been leading by three one-hundredths of a second. Here, the difference was four. All season long, nobody had come within five-tenths. That's fifty one-hundredths, not four! At the Olympics, when it really counted, Monique had turned up. Was I upset? I was so angry at myself, I felt sick. Other skaters could come to an Olympics and do a personal best. Why couldn't I?

I skated over to Bart. He put his arm around me, because he knew how I was feeling. I sat down on the mats that run along the edge of the track. I wanted just to be alone for a bit, or at least alone with Bart, so I could pull myself together. But you can't get away. There's this big camera eye that goes along the mats. I had to watch that it didn't come and focus on me, and I remember thinking I would be furious if it did, because I really needed a moment. But you know that cameras are everywhere, and you're in the middle of this bubble, so they can find you. There's no privacy.

Technically, I hadn't skated all that well. I hadn't had a great entry to the last inner, for example – that much I remembered. I lost one-tenth of a second there, maybe more. And that upset me, because it was so close. Just after me, Monique had skated an amazing race. Even Bart agreed with that. Yes, Monique had skated an unbelievable race. Okay, good for her! And I really do mean that – Monique is a friend of mine. But why hadn't I skated an unbelievable race? I was supposed to be peaking, wasn't I? I'd skated an okay race. Why *hadn't* I skated a personal best?

I went to the middle of the oval to take off my skates. I kept my head down, because I was crying a bit. Everybody was filing out, but you know people are going to be watching. I didn't want to go back to the dressing room, because I didn't want to be around other skaters.

Monique came by and patted me on the back. She had seen my race, and she knew I would be upset with myself. I said, "Hey, good race." She was just so happy for her race, and rightly so. I was still beating her, yet I was upset and she was excited. Because during recent weeks, nobody had come anywhere near this close. Four one-hundredths of a second! Anything could happen.

And then Sabine Volker came over, another German girl I'm really good friends with. She hadn't skated a great race, either. (The race on the second day is where she won a medal.) Now, she was sitting in fifth place. Sabine came over and said, "Don't worry, you'll be better tomorrow." Trying to help. But I was disgusted with myself. It wasn't until next day that I found Sabine to apologize, because I hadn't said a word about her race. And she said, "Catriona, don't worry about it." She totally understood. Because I felt so disgusted with how I'd skated. It's ridiculous, I know, because I was leading the race and I'd set an Olympic record. But I knew exactly where I could have done better, going into that last inner, and that made me disgusted with myself.

While this was happening, I looked up and saw one of the photographers poking a big fat lens over the wooden wall along the ice. I said to Bart, "Oh great, now somebody's taken a picture of me like this."

Let's say that I was not looking my best. We had decided before the race that I wouldn't talk to any media afterwards, because we thought there might be enough stress. We decided that we'd have a

media blackout. Leaving the ice, you go down the stairs and through a tunnel to the dressing room. Robert Bolduc, our team leader, had said that if you turn left at the bottom, you go past the media. If you turn right, you end up going behind the media. You don't see anybody, and nobody sees you. When we got to the bottom, I deliberately turned left towards the media area. That was the mood I was in. People do funny things under stress. I suddenly decided I wasn't going to hide, I had nothing to be ashamed of, and this was my way of showing that.

Beforehand, a couple of reporters had said to Bart, "Can we talk with you between races?" And Bart had said, "Well, Catriona's on a blackout." And they had said, "Fine, what about you? Will you talk to us?" He'd asked me, "Do you want me to talk to them?" I'd said, "It doesn't matter to me. Sure, you talk to them."

We walked past the media: "Oh, Catriona! Can we talk to you?"

"No, sorry." I kept going. "I'm on a blackout. I'm not talking to anybody."

Bart talked to the media for half an hour. And several people asked, "Is Catriona angry? Is that why she's not talking?"

"She's not angry," Bart said. "She's on a media blackout."

He explained that we had done the same thing at Nagano, during the last Olympics, because you've got enough stress already. You don't need to hear, "Oh, it's so close!" You know that already. You don't need to hear it from twenty people.

Later, Bart filled me in. He'd said, "Catriona's upset because even though she had the best time, and she's leading, she knows she could have done better. Her opener was good, but on the backstretch, she lost time. And that upsets her." According to the newspapers, Sean

said the same thing: "I thought she had a pretty good race. Not her best performance, but a decent race. She can be better and go faster. I expect her to have a better race tomorrow, technically speaking." And Monique Garbrecht-Enfeldt, who had skated an amazing race, had said, "I have a chance. But I think Catriona will come back tomorrow and skate even faster. She is the favourite, the chief – the boss of the 500."

At the time, I heard none of this. I got back to the dressing room and had to do doping. This did not help. I didn't remember having done drug-testing on the first day at previous Olympics. At this point, tiny things were upsetting me. I had to go and pee in a cup. And then do a warm-down. By now, it was late in the evening. The men had skated early in the afternoon. Why had they scheduled the woman so late?

You can see how wound up I was. Really, really tight. Or maybe it's more like steam in a pressure cooker. I needed to vent but couldn't. I don't mind getting upset in front of Bart, or even in front of my coaches, but I don't enjoy putting my deepest feelings on display in front of a million people. I had not skated my best and I knew it. Canadians were counting on me to turn these Olympics around, and now I was in danger of letting them down. That scared me so much I could hardly think about it. For sure, I could not talk about it.

Instead, I talked about how Monique and I were so close. Four one-hundredths of a second. Derrick Auch was there, my former coach. He said, "Catriona, look at Nagano. The margin was even narrower. Three one-hundredths! And you know that next day, you went out and you skated and won."

True enough. But in Nagano, I hadn't felt such pressure. Bottom line? What Derrick said did not make me feel much better because the narrow margin wasn't the real problem, even though I said it was. The evening dragged on, but finally we got back to the apartments. Our team physiotherapist and our massage therapist were in the support-staff condo, and we had a quick snack and then I agreed to have what we call a needling. It's something like acupuncture.

When we were doing that, Lorrie, the physiotherapist, said something about how the whole Canadian team was rooting for me, and bam! That triggered me. Something completely innocent, and I got upset: "I hope people aren't relying on any single person to change everything. It takes a whole team, you know!"

Lorrie guessed the truth then: "Catriona, oh! I'm sorry."

"No, no. It's okay, it's just me."

Obviously, the littlest thing was setting me off. By the time we got back to our own place, it was ten o'clock and I still hadn't eaten any supper, just a snack – so I felt frustrated because of that. Bart reminded me that I didn't have to go to bed until one, because I didn't have to wake up until late. He started heating up one of the dinners we'd brought.

Bart told me about how earlier, when he was finishing with the media, Monique's husband, Magnus Enfeldt, had come over to chat. Magnus had been all excited, of course. He used to skate himself, for Sweden, and he knew Monique had skated a great race, an unbelievable race. He also knew that I wasn't super-happy with the way I'd skated, even though I had the best time, and he said to Bart, "Tell Catriona that last year, at the World Singles, when we were here in Salt Lake, she skated against Monique – and that was when she broke the world record."

Magnus was right. That was when I had skated 37.29. And for him to say that was very decent, very classy. That's what Bart and I thought. Magnus was excited for his wife, but also he knew how I would be feeling, and he reached out. Sometimes, from great competitors, you get these classy moves. Bart reminded me of that. And for five minutes, I felt pretty good: "Yes, that was classy."

But then I thought again of my family, and how they had travelled such distances to show their support. I thought about how my parents and my sisters and their loved ones had spent hard-earned money to travel to Salt Lake City. And I thought about the folks back home. From the east coast to the west, and from the American border to the high Arctic, people I didn't even know, including many, many children, were watching every race, hoping and praying and cheering. For Canada, things had not been going well. If I skated badly, if I didn't win a gold medal, if I didn't turn things around . . . but you see how I felt.

17

The more races you win, the more pressure you feel. At least, that's how it is for me. Bart says it's because I'm chasing the perfect race. When I think about, I don't know if it exists, this perfect race. But I am a perfectionist. A lot of skaters are like that. You do the work. You work on power, endurance, technique. Then, at race time, you

try to bring it all together. If you can just skate a bit more perfectly, if you can shave just a few hundredths of a second off your time, that can make all the difference.

On Thursday, February 14, all day long I was up and down. I woke up feeling okay. I started eating my porridge, as I do every morning, but then I saw Bart looking at me, studying me, and all of a sudden I was upset. Bart knows me so well, he can see it in my face: "Catriona, just stop, okay? You go out and skate your own race, just the way you always do."

After breakfast, we put a movie in the VCR and tried to watch that. I don't remember what it was. I was trying to relax. Bart went over to the support-staff condo for something, and Sean Ireland was there. People were asking Bart, "How's Catriona?" And he was saying, "Okay."

But with a question in his voice. She's okay, sort of, more or less.

At one point Sean came to the apartment. He's a quiet guy. We sat in the living room and I drank coffee. Sean was checking to see if I was okay, and he knows I can hide things when I want. But I really was okay, especially when people were around, and as Sean was leaving, I told him, "Sean, hey, I'm fine. You know I'm fine." He said, "Okay, see you later."

It was nice that he stopped by. You need that support. I do, at least. As the race got closer, it was like I regressed. Again, I was twelve years old. I needed people to reassure me. I kept returning to the narrowness of the gap. Four one-hundredths of a second. I wanted four-tenths, not four one-hundredths. At some level, I knew that if I went out and skated a normal race, probably I would win. But this was the Olympics. What was normal about that?

"Look, you're the world record holder," Bart would say. "Seven times, you've driven down your own record. Monique calls you the boss of the 500. Yesterday, you had the second-fastest start of your career. You posted the fourth-fastest time of your life."

"On the backstretch, I skated badly."

"Nobody's perfect. Eight times, you've skated the fastest 500 ever recorded by a woman. Eight times!"

"Yesterday, I touched down a couple of times. Actually touched the ice with my hand! Can you believe that?"

"Today, you won't touch down."

"Monique had a PB."

"Catriona, you're going to go out and skate your own race. You're not going to worry about Monique. Why worry about her? Or anybody else, for that matter? You're the fastest woman on the planet. If anybody's going to break the record, it's going to be you! You came close yesterday."

"What if Monique skates another PB? What if she breaks my record?"

"Yesterday, you skated 37.30. Your fourth-fastest time ever. Even with a couple of mistakes."

"You admit it! You know I skated badly!"

"Monique has never skated that fast. No other woman has ever skated that fast. Let them worry about you, Catriona. They're the ones who've got something to worry about. What did that article call you? The Queen of the Five Hundred! You're the Queen of the Five Hundred, Catriona! Let the other girls think about that and . . . and tremble! Let them tremble!"

Bart knows how to make me laugh. We both laughed.

Ten minutes later, of course, I was back to feeling tense. Waiting is the worst – waiting all day to race. Next time, they should schedule the women in the morning. If somebody has to wait, let the men wait. Why not? It's our turn to skate early!

Waiting, waiting, waiting. What a relief to go to the Oval!

I got there a couple of hours before I was scheduled to race. Usually, I look at the pairing list and figure out what time I'll skate, give or take five minutes. Then I work backwards two hours. Today, I arrived a bit early. My race would happen at about six o'clock, and I arrived well before four. I went to the dressing room and put on a training suit and a sweatsuit to do my warm-up. Usually, I jog, I stretch, I do calisthenics. At Salt Lake, there's no running track around the ice, like in Calgary. You go to the middle of the oval and there's a large concrete area, and that's where you warm up. I jogged around there, getting loose. A couple of Dutch reporters I'm friendly with, and who know a lot about skating, were sitting in the media area. They gave me a thumbs-up and I waved.

Then I saw some Canadians, saw my parents, my sisters, and they were all waving and urging me on. Once you're in the environment, and you're not just sitting there, waiting, waiting, waiting, you start feeling better. After a while I put on my skates and went onto the ice to warm up. I powered around for a few laps, not pushing too hard but staying low, and Sean Ireland said, "That was awesome!"

Suddenly, I felt great. The ice felt grippy, the way it does in Salt Lake, and skaters love that. It makes you feel powerful. So as soon as I began wheeling on that grippy ice, I felt stronger. After warming up, I returned to the dressing room and changed into the flashy red

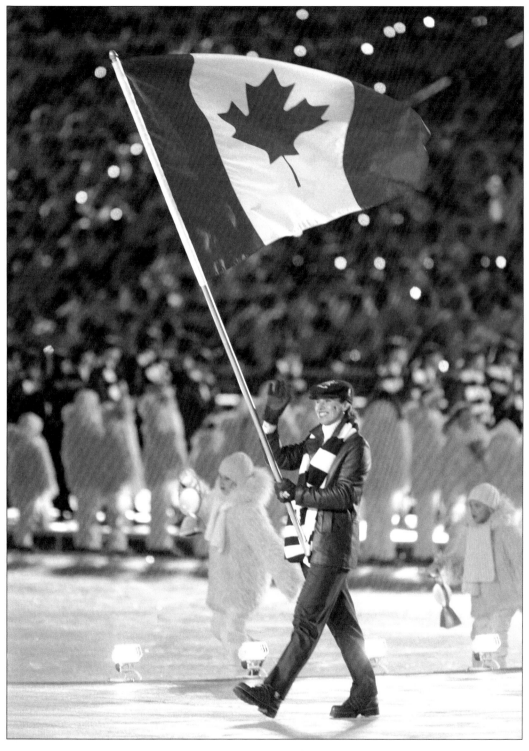

Salt Lake City, Utah, 2002. Carrying the Canadian flag during the opening ceremonies of the Olympics. How the crowd roared as we entered the stadium! (*Mike Ridewood*)

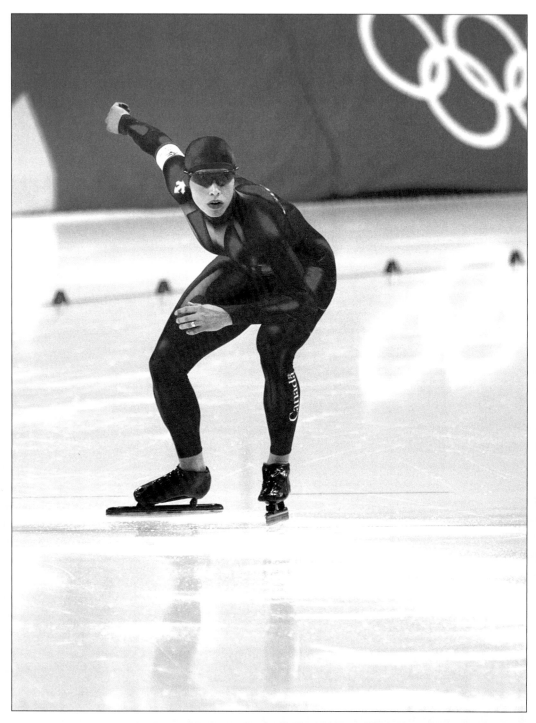

The Salt Lake Olympics. Note the white armband. That's worn by the skater who starts in the inner lane, and so tells me that this is Day Two – my second 500-metre race. I have played with my rings, adjusted my glasses, and slapped my legs. Now, I am in the ready position. (*Kristian Bogner*)

Skating hard down the backstretch in that same race, I am thinking, "Patience, power, stay low." I finished in 37.45 seconds – the best time of the day, and fast enough to win an Olympic gold medal. (*Kristian Bogner*)

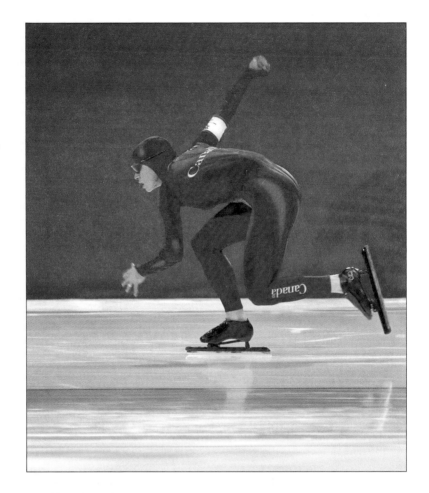

All flowers, medals, and smiles with Monique Garbrecht-Enfeldt and Sabine Volker, the superb German skaters who won silver and bronze. We stay in touch by e-mail, and will compete again in World Cup events and in the 2003 World Sprint Championships in Calgary. (*Kristian Bogner*)

Celebrating the gold at the medal ceremonies. A moment later, when they played the national anthem, I was wiping tears out of my eyes. (*Kristian Bogner*)

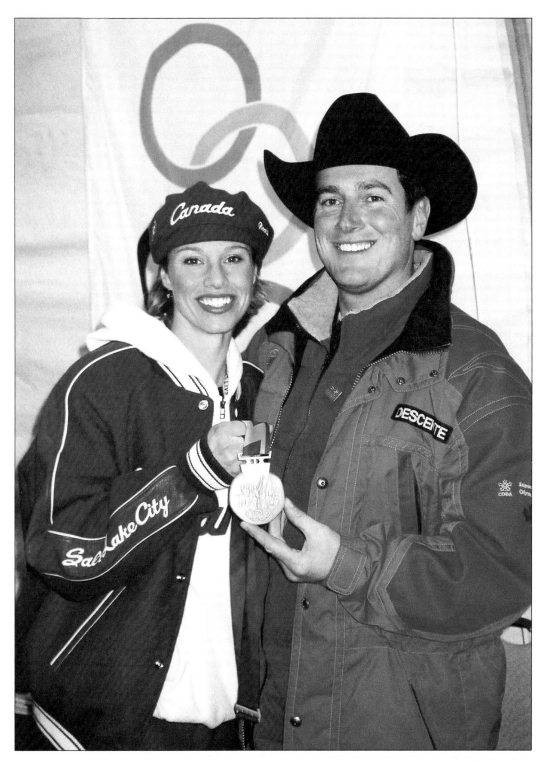

Five minutes after the ceremonies, in the Green Room where athletes and performers congregate, I showed Bart the Olympic gold medal. He couldn't believe how heavy it is.

These Canadians, free of stress at last, are making their way to the closing ceremonies.

In Salt Lake, after I had skated the 1000 metres, I got together with the most important people in my life: (*clockwise from left*) Kevin, Emma, me, Bart, Fiona, Ryan, Mum, Dad, Ailsa.

Sabine Volker and me in the Green Room at Salt Lake City, waiting for the medal ceremonies. She's modest, genuine, and a great competitor.

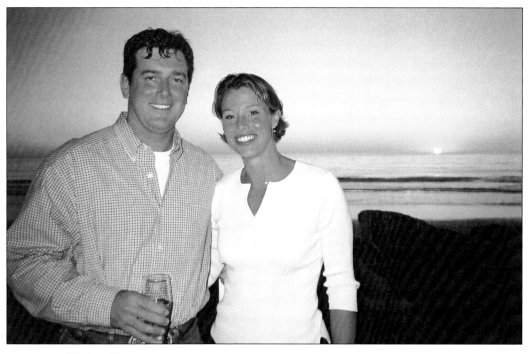

San Diego, California. Bart and I are enjoying a bit of a holiday. We're getting ready for dinner as the sun sets over the Pacific Ocean.

Toronto, 2002. It was a struggle to find the right dress, but finally I'm walking down a red carpet to join figure skater Kurt Browning in co-hosting the Walk of Fame Show for Canada Day. (*Ernest Doroszuk*, The Toronto Sun)

and blue racing suit that Canadian skaters were wearing. Strange as it sounds, a suit like that can help. Suddenly, you're a superhero. You're Spider-Man! You're Wonder Woman!

Sometimes you feel great in warm-up, but then you get tense. For sure, I was tense as I went to the line to race against my friend Monique. I like her a lot, but she was skating for Germany. And me, I was skating for Canada. It's strange, the things that can happen when you race. We moved to the line, and then, in the ready position, I was wobbly. I'm never wobbly! Watch the video, it's unbelievable. Sometimes you twitch, but I was rocking, almost. I remember feeling surprised that we didn't get a whistle to restart. And I don't know if I was going back or forward when bam! the gun went off. You can hear the cameras clicking as you move to ready, and I was thinking, "Stay low."

We've been taught since forever that if the gun goes off, you don't stop skating – not even if you think the race might be called back because of a false start. If it's called back, they shoot the gun again or else they whistle. You can get caught thinking, Ooohh, I've wobbled, or Hey, I just saw the other skater wobble, or you move a bit, so you think they're going to call back the race. Your instinct is to think about that. But we've been taught: you go until you hear a gun or a whistle. When I watch the video, I can't believe the amount of move-ment I had.

I don't think I false-started, but they could have called it because I was rocking a bit. I don't know it if helped or hurt, because when you watch the video, you have to wonder if I wasn't rocking back-wards a bit. And that can hurt you. Regardless, I thought, Okay, just go until you hear something. But there was no whistle, no gun. I

meant to ask Monique if she had seen me wobble, or felt anything, but everything was such a whirlwind. I don't remember the race clearly, just bits and pieces, probably because I was so tense.

Despite the wobbling, I had a fast start. Then, after about 300 metres, I tightened up. It was hard not to think about where Monique was, and how she was skating, and the crowd was loud. I knew it was coming down to the last 200 metres. I had started on the inner, so I was on the outer at the end. I prefer that because you don't see the other skater, so you're not going, Oooh, where is she? and you go down the backstretch first. I remember going into the last hundred, and then the last fifty, and I knew I was ahead. And with fifty, then forty metres to go, I knew that even if Monique was gaining, she wouldn't be able to catch me. I knew the race was mine – and that Canada had its first gold medal of the Salt Lake City Games.

I knew that because I had seen the key races before ours. You try not to watch, but you can't help seeing bits. I had seen Sabine Volker skate an amazing race, and before we skated, she had been sitting in first, so she knew she had a medal. I hadn't seen Andrea Nuyt skate, who had been sitting in third, just behind Monique, but people told me she had slipped a couple of times. That must have been hard for her, because she had skated a good first race and then had a rough second race, and that's a hard place to finish, fourth. Just out of the medals.

Also, I had seen the times. Almost everybody was skating slower than the day before, maybe because of the ice, maybe because we'd grown tired. I had finished in 37.45 – not a great time, but the best of the day by nineteen one-hundredths of a second. It was good

enough to win. My two-day time was 74.75. Monique stood at 74.94 and Sabine at 75.19. Canada had won its first gold medal!

I skated a lap, coasted really, trying to catch my breath. Bart and I had talked about what would happen. I wanted to give him a big hug, but he was on the wrong side of the mats that line the track. When I coasted past, I pointed, indicating that he should go to the break in the mats. That's why everybody who has seen the video sees Bart jumping up and down, then running up these little stairs – because he was heading to where we could hug each other. In the stands, everybody was yelling and screaming and so excited. Canada's first gold!

My family, I think, was just relieved. They were all on their feet – Mum and Dad and both my sisters, Fiona with my brother-in-law, Kevin, and their two little kids, and Ailsa with friends from San Francisco. A couple of Bart's rodeo buddies had decided to come and see the Olympics, so they were cheering, too. A few people had tears running down their faces.

When you cross the finish line, you still have a ton of speed going from the backstretch, and I remember Sean and Robert were excited, and as I coasted past we did a high five. I continued around, waving, and I blew kisses to my family, and then when I came around to the backstretch, Bart was there, and I gave him a big hug and a kiss, and I gave Sean a hug and Robert a hug, because the coaches, the support team, they're all so much part of it. Especially Bart, of course. Because obviously I hadn't done this alone.

Then, the whirlwind hits. Suddenly, you have to do this, this, and this. First, we had the flower ceremony, because we weren't going to get our medals right then and there, at the venue, but later,

downtown, at the medals plaza. This was a different set-up. To tell the truth, I found it disappointing. The medals plaza was amazing, but all these skating fans were already there in the venue. They had bought tickets to watch this particular race, and now they weren't going to see a medal ceremony.

Still, the flower ceremony was lovely. They staged it exactly like a medal ceremony, but they gave us flowers. They brought us to the podium, me and Monique and Sabine, gold, silver, and bronze, but they didn't play the Canadian anthem. I have to admit I felt a bit sad about that. After the ceremony comes the victory lap. I skated onto the ice. From the stands, Kevin threw me a Canadian flag. Nobody was allowed to bring long poles into the Oval, for security reasons, so it had a short handle. I picked it up, and Kevin was yelling and pointing, so I looked . . . and just for a second, it was upside down. The Canadian flag! Oops!

Then Kevin threw me the Saskatchewan flag, the Tiger Lily, because at Nagano, I'd carried that as well. Mum has brought that same flag to every Olympics, to Lillehammer, to Nagano, and she had given it to Kevin to throw. So I picked that up. And everybody's yelling and screaming, the whole place is in an uproar. And one thing I didn't realize until weeks later, when I went to Saskatoon, because then people told me: "When you carried the Saskatchewan flag? It was upside down! It was upside down the whole time!"

Most people were saying, "Oh, look! The Saskatchewan flag." But I've checked photos, and you can see the green and the yellow, and yes, that's the flag – but it's upside down! Everybody in Saskatoon said, "Ah, who cares? What matters is that you carried it!"

By this time, Bart was standing inside the oval. I skated half a lap, and then he ran to the backstretch, so there he was again. In

Nagano, when I'd skated my victory lap, Bart had wanted me to put on his hat – this big, black cowboy hat he always wears. And I'd said, "Oh, I don't know. Should I?" I'd decided not to take it, because I felt that, somehow, it wouldn't be right.

Now, in Salt Lake City, skating my victory lap, I come around into the backstretch and here's Bart holding out his hat: "Take my hat!"

This was not something we'd discussed. Suddenly, he's saying: "Take my hat!"

I'm thinking: "Should I? No way." By now, rock music was blaring over the loudspeaker system, I think it was *We Are the Champions* by Queen.

"Take my hat!"

Should I? No way. Should I? No. But then Bart said it again: "Take my hat!"

And I don't know what happened, but I heard myself say, "Well, okay!"

So I took his cowboy hat and put it on my head, and I skated the rest of the victory lap like that, with the music blaring, carrying this huge Canadian flag, and this tiny Saskatchewan flag, and wearing Bart's big black cowboy hat. Afterwards, that was all we heard about: "Oh, it was awesome when you took Bart's hat! Just so great!"

Later, Bart hugged me: "See?"

Because he had seen me hesitate. Should I? No. Should I? No. Should I? Afterwards, again and again, people mentioned that hat. In fact, that was all we heard about. Not the race. Not the flower ceremony. But "When you put on Bart's cowboy hat? And skated around with the Canadian flag? That was the moment! The tears just poured down my cheeks!"

V

THE HOME STRETCH

18

❖❖❖❖❖

"I hope this gives everyone more confidence," I said at the press conference immediately after the race. "We had an unfortunate five days or so, with the figure skating and Jeremy falling. For Canadians, it's been an up-and-down week. But we're not even halfway. With all the events still coming up, I hope this gets us excited again – that it's the beginning of some great results."

That's what I wanted to communicate: "Hey, people! We can do this!"

Later, the Canadian media reported that my gold medal turned the Olympics around. That afterwards, the team regained some of its swagger. I wouldn't put it that way. But I did get a sense that afterwards, Canadians breathed a sigh of relief. Whew! In the support-team condo, people said that's what should have happened. All season long, I had dominated the 500 metres, so I should have won gold. Finally, something that should have happened did

happen. Because Jeremy's fall was just so weird. And Jamie and David getting the silver when they deserved the gold? Unbelievable!

At that press conference in the media zone, which was more like a scrum, somebody asked me, "What if you had lost? Would you have been disappointed?" I answered that if I'd won a silver medal, I would not have lost, exactly. But if I hadn't won gold? Yes, I would have been disappointed. Because, given how I'd been skating, it would have meant I hadn't skated my best. Also, I knew that so many people back home were cheering and praying for me. If the race hadn't gone as it did, I know they would have been disappointed, not at me, but for me. And I would have felt disappointed for them – and that I had let them down.

After the press conference, I went to the dressing room to spin on the stationary bike. I had to do this two-and-a-half-minute program because I would be racing in the 1,000 metres. Sean Ireland was there, and Derrick Auch and Dave Smith, and we were all laughing because it was like, well, congratulations on the gold medal . . . now let's sit you down on this bike and train you hard. We were laughing, I guess, because we all felt it – that feeling of relief. At last! Something had turned out as expected!

This bike program was designed to engage the systems we would use in the 1,000 metres, the aerobic power system or the anaerobic system, or maybe both. At some point, you have to leave it to the coaches. This was going to help us in the final lap of the 1,000 metres, and that's all I needed to know. It wasn't easy spinning, either, because it's progressive, and they're turning up the resistance as you go, so it gets harder. And you're thinking, If only people could see me now. Half an hour after winning a medal, I'm still in

my skinsuit and training so hard that sweat's rolling off my forehead into my eyes.

The doping people are still with us, of course. The drug-testers include a woman who can't leave my side from the time I finish racing. She's "my shadow." We go from the biking to the dressing room, so I can drop off my skates, and then we go to the doping room. You have to have a team official with you. Sally, our massage therapist, had already asked, while I was doing the press conference, if we could do the doping downtown, which was forty-five minutes away. That's where the medal ceremony would be, and because of the late start time, we were running late. And they told her, No, you have to do doping here, before you leave.

So we started that process knowing we were tight for time. We're filling out forms and I'm changing into my podium wear, and the doctors are saying, Look, we have to take our time with this, and do it right. And they're right. You can't rush through doping, because what if something goes wrong? First you pee in a cup, and then you separate the urine into an A sample and a B sample, and also you fill out these forms, listing any vitamins or supplements you've been taking. You have to do all this yourself, because nobody else can touch your sample. You've done it a thousand times, you know the drill – but this is an Olympics. You have to take an extra couple of minutes.

When all that's done, we run to the van – myself, Bart, Sally, and our press attaché, as well as a couple of people from SLOC, the Salt Lake Organizing Committee. We're heading for the medals plaza downtown. It's a good thirty- or forty-minute drive, depending on traffic. The SLOC people are radioing back and forth: Yes, we're

on our way. What do you mean, we're running out of time? We're almost there! Meanwhile, my family has rushed downtown, because they don't want to miss the medals ceremony.

You can see how this would be frustrating. Your family and friends have been at the venue. They've seen you win a medal, but now they have to travel downtown, maybe walk a ways, and then stand outside in the cold and wait. It's hard for older people. I'm not saying my parents are old, but they're not in their forties, either. So this is hard for them. And it's cold out. And as we arrive, we hear sounds and realize that Sheryl Crow has started to perform. We've missed the ceremony by five minutes.

The German girls who had won silver and bronze, Monique Garbrecht-Enfeldt and Sabine Volker, had already arrived. They had been told they could do doping downtown, after the ceremony. In fact, back at the Oval, as we were leaving the doping room, one of the workers said, "Why didn't you do this downtown?" Sally looked at her and said, "Because we were told we couldn't! That we had to do it here."

Immediately, I went and apologized to Monique and Sabine: "Sorry, guys! So, so sorry! They told us we couldn't do doping downtown – that we had to do it at the Oval." Fortunately, because they are not just great competitors but also good friends, they understood completely. When you're dealing with something as complicated as an Olympics, mix-ups do happen.

Organizers had decided we could receive our medals the follow-ing night. For a moment I panicked, because Bart and I had tickets to the men's hockey game, Canada versus Sweden. We had bought them the previous summer, paying $175 American for each of them

– close to $500 Canadian for the pair. But the medals ceremony was scheduled long enough after the hockey game that we would have no problem. The worst of it was that my family and friends had to make a whole second trip downtown, and again stand outside in the cold. What can you do? Grin and bear it.

For Bart and me, the adrenaline was still going. We ended up doing more media, more interviews and photos, and didn't arrive home until two o'clock in the morning. We weren't sleepy, and we both felt starved, so we jumped in the truck. We had spotted a little Mexican place that was open twenty-four hours, so we went and got some Mexican food and brought it back to the apartment. We didn't get to bed until 3:30, and then we were up four hours later. I was still so pumped that I couldn't sleep, and Bart was no better.

I had a day off from training, so we planned to hang out in the morning and then go to the hockey game. Later, someone would meet us and take us to the medals plaza. I ended up not minding that the ceremony had been delayed, and feeling almost that the change was a blessing in disguise. First, I was showered and didn't have "hat-head" when I mounted the podium. Second, I was able to take the day and realize what had happened, let events sink in, and get excited about the ceremony.

I still felt bad that my family had to travel downtown and stand outside in the cold. And they were stuck off to one side, behind a cattle gate. It's hard on families, because you would like to have them right there beside you – but 20,000 other people want to witness the event, so what can you do? We did enjoy a beautiful ceremony. We had been hearing how big and heavy the medals were, but until I received mine, I hadn't imagined. When I mounted the

podium, they played the Canadian anthem, "O Canada," and people sang along – everybody who knew the words. People were dabbing at their eyes. Another great moment!

A couple of days later, on February 17, we raced the 1,000 metres. I drew the outer lane to start. Like most skaters, I would have preferred the inner. When you analyze results, you see that most winners start on the inner lane – and that's among both men and women. People have been suggesting that soon we'll be skating two races in the 1,000 metres, starting one in each lane, just as in the 500 metres, because of the advantage you get with that first inner.

At Salt Lake, I was racing against American Chris Witty. She's best at 1,000 metres, and I knew she would have a good race. As skaters, Chris and I are almost complete opposites. I'm fast at the beginning and not so fast at the end. Chris doesn't have the top-end speed, but she builds momentum all the way through the race. I'm more of a pure sprinter, and I knew my only option was to go for it – to get so far ahead that Chris couldn't catch me. My first 200 metres was great, and I was skating well. My lap time was good. In fact, I skated the fastest 600 metres of my career.

Then, with one lap still to go, I began to tire. Looking back, I can see that maybe the run-up to the 500 metres had taken more out of me than I'd realized. Maybe I'd gotten that first 600 metres too much from excitement, and not enough from relaxing and skating. Either way, on the backstretch, I could tell that Chris was gaining, just reeling me in, and on that last outer, it's depressing when somebody whips past you. That's what happened. And so, even though my time was nearly two seconds under the previous Olympic record, I finished ninth. Chris Witty won gold and set a world record of 1:13:83.

Later, she said I had helped pull her to that with my fast early pace, and I thought it was nice of her to acknowledge that.

If I had kept it together better when she passed me, I might have ended a few places higher. Looking at the times, I think that if I had been at my best, I might have reached the podium. But I had no saliva left, and no oxygen. For that day, what I did was the most I could have done. I knew that, and I was proud of that. But then you go through the media zone, and they look at ninth place, and say, "Well, that's not very good." But that really was the best race I could do that day, after the excitement of the 500 metres and then the closeness of the first-race results. The stress had taken whatever extra I might have had. Bart said, "Catriona, I'm so proud of you for going for it!" I had given until I had nothing left to give. I knew it and Bart knew it, and I was happy with my results. I had done the best I could.

Right after the race, when the flower ceremony was going on, a few of us were sitting on a bench inside the oval, and we had to laugh. Like me, Monique had died more than she'd wanted, and the same with Svetlana Zhurova, another pure sprinter. Our lungs were killing us. When you've pushed that hard, you actually feel pain, and you can taste your own blood. So we sat there laughing, because we were dying, and yet we were all in the same boat. There was nothing more any of us could have done. We were finished for the Games, all three of us, and there we were, sitting in the middle, dying and laughing at the same time.

Once my two events were finished, Bart and I could go and cheer on other Canadian athletes. And I love that. I love being a spectator, being able to go to an event in normal clothes, and then

being excited for everybody and cheering. I know that, when I am retired, I'll be a good spectator. I enjoy being not so nervous and experiencing slightly less anguish. Speed skating, short-track racing, cross-country skiing, men's and women's hockey – you name it, Bart and I were there, hollering.

We were thrilled when, for the first time in Olympic history, organizers overturned a figure-skating jury's results and awarded Jamie Sale and David Pelletier the gold medal they had earned. And it's a funny thing about momentum. Once Canada started winning, we didn't stop. For those who count medals, we ended up with seventeen – not the twenty that some commentators had predicted, but two more than the best Canada had yet done. Overall, we finished fourth – one place better than we'd achieved at Nagano, and immediately behind Germany, the United States, and Norway. That's not too shabby, considering our relatively small population.

The climax came when, after a shaky start, the Canadian men's hockey team won the final game against the Americans and brought that gold medal back to Canada for the first time in fifty years. The Canadian women's team had already triumphed, and this was the first double hockey gold for any country in Olympic history. We'd managed to find tickets to most of the men's games, although we ended up watching the women's final on CBC because the only available tickets cost more than $200 each. As for seeing the men's final, some people call it one of the greatest hockey games ever played. I'll never forget standing there with Bart as the Canadian anthem played and the tears rolled down our cheeks.

After that, we had to decide whether to wait for the closing ceremonies. I had decided to drive home with Bart, taking the time to wind down and enjoy what we had accomplished together. Part of

me wanted to get on the road right away, but I didn't want to feel regret later on and wish that I had stayed. That would haunt me. So we stayed and I went to the ceremonies and it was great, just being with that Canadian team for the last time.

After the ceremonies, I collected my bags from the village. Bart had spent the past two days packing the truck, a half-ton Dodge Ram that Chrysler had lent us. We'd also rented a U-Haul trailer, if you can believe it – that's how much stuff we'd brought. From the Olympic Village, I went to the apartment to pick up the last of the gear. I looked at my watch as Bart and I drove north out of Salt Lake City. It was midnight. We were heading for Canada. We were going home.

19

❖❖❖❖❖

Life is like a 500-metre race. If you don't relax and pay attention, you'll miss the whole thing. When I look back even a few years, I realize how much I've forgotten. I should have written things down, maybe kept a diary. But I didn't – nothing beyond my training diary, in which I scribbled brief notes and advice to myself: "Arrived Nagano." Or "Skate aggressively." And so, all along, I have been scratching my head. Did this event happen first? Or that one? Old newspaper clippings have helped. Fortunately, as we move closer to the present, remembering gets easier.

After leaving Salt Lake City, Bart and I drove north for three hours before the roads got bad – snow-blowy and icy. We're talking February in the Rockies. Even Bart, whose idea of a good time is to grab a hard-charging steer by the horns and throw him to the ground, even Bart had to admit that driving was dangerous. We found a motel in Pocatello, slept for six hours, then got back on the road. When the weather is good, you can drive from Salt Lake to Calgary in fourteen hours. With Bart at the wheel, maybe slightly less. But we encountered patches of black ice, spotted vehicles in various ditches, and didn't make it home until midnight.

Next morning, we were travelling to Toronto. I had been invited to drop the puck at a Maple Leafs hockey game. Bart is such a gung-ho Leafs fan that on the front of his truck, a one-ton truck, he sports a Maple Leafs licence plate. This is in a city that bills itself as the home of the Calgary Flames. We are talking serious risk-taking. So, no – no way we were going to miss that hockey game. To tell the truth, I felt exactly the same. So what if it was midnight? We unpacked the truck, did our laundry, and crawled into bed around three in the morning. A few hours later, we boarded that airplane.

We enjoyed a great hockey game in Toronto, spent the night at a hotel, then flew home to Calgary. I had decided to take a miss on a World Cup meet in Oslo, Norway. It was just too soon. I spent four days at home, unwinding, seeing friends. Also, I got back on the ice at the Oval. Then I flew to Europe, caught up with the rest of the Canadian team, and skated at Inzell, Germany, in the final World Cup meet of the year. Inzell is an outdoor venue, and it was the perfect place to end the season. The sun was shining. The temperature was in the mid-teens and spirits were high. I felt fresh, skated well, and managed to defend my title in the 500-metre

World Cup event. I also won my first 1,000 metres of the season, which was a nice way to end the year.

I had enjoyed a dream season. In the 500 metres, I had equalled my Nagano year, finishing as world sprint champion, world cup champion, and Olympic champion. As well, I had won nineteen of my last twenty races. Although I had failed to take an Olympic bronze in the 1,000 metres, I had lowered my world record in the 500 metres for a seventh straight time – to 37.22 seconds. And on my home track! I had driven down the Olympic record to 37.30, while establishing a two-day mark of 1:14.75.

Also, I had become only the second female skater ever to win consecutive Olympic titles at 500 metres. Bonnie Blair had won three in a row, and people asked if I would try to match that. The answer is no. Blair happened to hit three Olympics within six years, 1988 to 1994 (Calgary, Albertville, Lillehammer), and that scenario is not likely to repeat. On the other hand, in January 2003, the World Sprint Championships will be held in Calgary. Barring the unforeseen, I look forward to defending my international title before a hometown crowd.

The competition will be fierce, of course. Monique Garbrecht-Enfeldt and Sabine Volker will be there, and probably Svetlana Zhurova of Russia, another great competitor. Svetlana got married last year, and she's in something of the same boat as me. She's planning to skate one or two more years, although she has said, Well, if I get pregnant. . . .

So a few of us are around age thirty, either just below or just above – women who are married and starting to think beyond skating, maybe to raising families. How long can people remain competitive? That depends on the individual, and to some extent,

on heart. Physically, judging from the way I feel, I could keep going for a while. I know more about my body now. I know how to train. I know what's best for me. I have suffered almost no injuries – just one tough year with my foot.

But you have to wait and see. Svetlana's in a slightly different situation. Salt Lake City was hard for her, because at 500 metres, she has been so competitive, always finishing in the top few. But then to come away from the Olympics without a medal – that had to be difficult. On the World Cup circuit, she finished second, ahead of everyone but me. What happened? An Olympics. If you don't have your best race, or if other skaters have better races, well, only three of you can win medals. And there are more people than that near the top.

That's why I have to laugh when Monique Garbrecht-Enfeldt calls me "the boss" of that distance. If there's a dividing line between the 500 metres and the 1,000 metres, I'm a tiny bit on the inside towards the 500 metres – but just a tiny bit. I have held the world record in the 1,000 metres and, back in 1997–98, until the Nagano Olympics, I actually held the record for the 1,500 metres. That's different, I know, from what I've done in the 500 metres. For three or four years, from 1997 to 2001, I was the only woman to skate that race under 38 seconds. But then last year, half a dozen women got under that barrier. Maybe it's time to think about driving the record below 37 seconds. That alone would be a good reason to stick around for at least one more season, just to see what happens.

Meanwhile, after the Salt Lake Olympics and before I resumed training, I did a lot of endorsements and public appearances. That is something I really enjoy – especially when we get to travel abroad. Last April, I spoke in Costa Rica, and Bart and I tacked on a short

holiday. I've been speaking publicly since 1994, when I took a weekend workshop organized by the National Sport Centre. For starters, you had to stand and introduce yourself to athletes you didn't know. By the end of the weekend, you've given a talk, you've been videotaped, you've analyzed the tape, you've counted how many times you say "um," you've seen if you use your hands.

I found it intense but I learned a lot. After that, with a couple of other athletes, I toured around Alberta, speaking at schools. That was a good transition. This was right after Lillehammer, when I'd fallen in the 500 metres. A big insurance company, Metropolitan Life, had decided to sponsor a dozen up-and-coming athletes, and they included me among them. After a devastating year, here was a company saying they were willing to help me out. I appreciated that – not just financially, but emotionally. The program lasted four years, and then Met Life was bought out and dissolved in Canada.

I had been doing some speaking for them, and in 1998, they brought Bart and me to their annual sales conference in Tucson, Arizona. I spoke there, and then I started speaking to more business groups. At first, this was a bit scary – travelling to Ottawa, for example, and speaking to higher-ups from CP Rail. But after a while I realized, I could do this! Put me anywhere and I'll be okay. Now, whenever I'm not training or racing, I do a fair bit of speaking. Right after Salt Lake, for example, besides Costa Rica, I spoke at events in Calgary, Saskatoon, and Brandon, Manitoba, and also in Vancouver, Toronto, and Chicago. For a while, I never stopped travelling.

So I wouldn't call myself a homebody, exactly. On the other hand, I am definitely a family person. After Salt Lake, Bart and I took a holiday in Scotland. Again, we just decided to ignore the demands. We went to Tayvallich and spent a week in my dad's

A-frame, visiting the extended family. Back home in Calgary, we see a lot of my sister Fiona and her husband, Kevin, and their two kids, Ryan and Emma. Kevin's a geologist. Back in 1992, after getting married, they lived in California. My other sister, Ailsa, is living there now. She's a geologist, and she loves California, and the only problem with that is we don't see enough of her.

Fiona and Kevin liked California, and they lived comfortably in both Los Angeles and San Francisco. Like Mum, Fiona is a French teacher. She did some teaching in California, and got to know the school system, and in 1997, after Emma was born, they decided to move back to Calgary. They wanted to raise their kids in Canada, and Ryan was already two years old. So one weekend, Kevin flew north. He wanted to buy a house. He phoned a real estate agent, and then Kevin, Bart, and I drove around northwest Calgary looking at houses. Kevin picked the one he liked best, said it was perfect, and bought it.

Soon after that, while I was competing in the Nagano Olympics, Fiona and Kevin moved back to Calgary. After the Games, they brought the kids to meet me at the airport. All kinds of media people turned up as well, and photographers took pictures of me with Emma and Ryan in my arms. Since that day, people have said, "So, you have two kids?" And I have to keep explaining, "No, no. You saw that photo? That was my niece and my nephew."

A couple of years ago, Bart and I decided to buy a house. We started looking around the university, because that's where the Oval is, and we both spend so much of our time there. When we saw the prices and what we could get for our money, we started looking farther out, and we ended up buying a place just a couple of blocks

from Fiona and Kevin. It's very like the neighbourhood where we were raised in Saskatoon, and where my mum still lives.

My dad lives in both Saskatoon and Calgary, and we see him quite often, although with his business, Metallurgical Consulting Services, he still travels a lot. Although my mum and dad went their separate ways a few years ago, they remain close, and they see each other at different skating events. They're both so strong-minded that it's amazing they were able to live together as long as they did.

Also, we see Bart's family. They live three hours from Calgary, but we visit whenever we can get the time. It's hard because when I'm training, I get only Sunday off each week. I'm still active with Athletes in Action, which promotes Christian values in sport, and I love to attend our church, Northside Friends. I've also been part of the "spirit of sport" campaign run by the Canadian Centre for Ethics in Sport, so I've made appearances at schools and malls promoting drug-free sport.

Back in 1995, I was invited to play golf at a charity tournament. I had so much fun that, along with Bart, I took it up. Bart's stronger than me, and hits the ball farther, but I'm a perfectionist, and very stubborn, and any day now, I hope to break ninety. Another recreation I love is horseback riding. A few years ago, Bart got me a beautiful young horse called Threepar. I rode him a bit but quit that, temporarily, after he bucked me off. I didn't get seriously hurt, just shaken up.

In early 2002, I read an article about the pop singer Jewel, who got bucked off a horse belonging to her rodeo-star boyfriend. She broke her collarbone and one rib, suffered cuts, bumps and bruises, and ended up wearing a collar and sling for four weeks. Bad enough

for a singer, but for a skater? One fall like that and your season's over. For the same reason, although I love getting out into the mountains, I don't downhill ski. Until I finish skating, riding and skiing will have to wait.

In December 2002, I turn thirty-two. When you've been doing something for twenty or twenty-two years, and you love it, you know you're going to miss it when you leave. Yet there does come a point when you have to take the next step. I can hear the ticking of the biological clock and don't want to wait too long. For sure, Bart and I hope to start a family.

Beyond that, I just don't know. Coaching has always appealed to me. Also broadcasting. Maybe I'll go into television and do sports commentary. Or maybe Bart and I will open a bed and breakfast. Last summer, the university gave me an honorary doctor of laws degree, and that was terrific. Still, I would enjoy taking some more university courses, and maybe finishing a degree in sociology.

Also, I've mentioned how I enjoy speaking, and who knows where that might lead? After Salt Lake was a lot like after Nagano, when I did the Dini Petty show, I went to the Gemini awards, I dropped the puck for the Maple Leafs, I had my picture taken by a modelling agency. Crazy stuff. That's when I realized these are not real-life things to me. Skating has taught me another thing: if you're going to do something, try to have fun with it. Even if you're competing at the highest level, for me, it has to be fun.

Not everybody sees it that way. A couple of years ago, a young Dutch reporter came up to me looking perplexed. He asked, "Why are you smiling?" This was just before the last race of the World Championships. My smiling troubled him because in Holland, racing is serious business. Speed skating is Holland's national sport.

If you're not winning races when people think you should be, you're going to get a rough ride in the press.

So it freaked out this reporter to see me smiling and enjoying myself before a race. He was seriously puzzled, almost upset. How could I be like that? To me, smiling comes naturally. If you look at old photos, you can see that my smile was practically adult size, the same size as today, by the time I was four years old. My sisters would tease me about it. My brother-in-law, Kevin, says I grew up into my mouth, and I think that's true. Anyway, I wouldn't want people to see me frowning all the time. Sure, I have my days when I'll close the door and throw a little fit, but usually the only person who experiences that is Bart. What can I say? I try to compensate in other ways.

Bart loves it when I win big races. Like me, he also enjoys the reactions. Most people never get a chance to see Olympic medals, and they like to touch them. I don't mind. Whenever I give a talk, I bring the medals with me. Some people say I shouldn't do that, because I might lose them, or someone might steal them, but I don't worry. The medals never leave my side. The older ones, from Nagano, are starting to look a bit rough, because carrying them, I've banged them together. They scratch, and if that's not bad enough, they're starting to peel. Probably I should leave them in a box, and not let them disintegrate, but people just love to handle them.

At home, I keep the medals tucked away, but not in a safety deposit box or anything. It's not the medals themselves that mean a lot, but what I did to bring them home – what happened at Salt Lake, what happened at Nagano, and what got me to those competitions in the first place, the journey itself. For sure, I like having my name in the record books. Even if people don't remember my name,

anybody who traces the history of speed skating will come across it. Twenty or thirty years from now, somebody who isn't even born yet will look back and say: "Hmmm, so this girl won those races in such and such a time." I know this because that's exactly what I did. And when I look back at the history of my sport, that's what I find interesting. Who did what? When, where, and how?

Okay, so I love setting records as much as I love winning medals. But to make it worthwhile, all the training, the pressure, the sacrifices, records and medals would not be enough. For me, it's how people respond. When you're competing at an Olympics, you know people are watching. But you don't realize the scope of the response until you come home and see how excited people are, and how much they appreciate what you've done. When you see that you've made an impact, a contribution, then the sacrifices feel worthwhile.

I remember 1998, for example, when shortly after the Nagano Games, people at a luncheon in Saskatoon announced that the city was naming a street after me. That was thrilling. I'd known there was a drive named after Diane Jones Konihowski, one of my heroes, but to get my own street! They showed me a map of a new subdivision called Silverspring, where my name would appear not on one street but on three: Le May Crescent, Le May Court, and Le May Place.

The following summer, when we were visiting Saskatoon, Bart spotted this advertisement in the *StarPhoenix* for an open house on Le May Crescent. My dad had joked that Bart and I should buy a house on one of those streets. We had no intention of doing so, but on the Sunday, as we started the drive home to Calgary, we decided to swing past and look. We found the street and, sure enough, there was a street sign! Bart made me jump out of the vehicle and stand

underneath this sign with my name on it. So I'm standing there feeling foolish, and Bart is fiddling with the camera, and people are driving by, staring at me, wondering what on earth is that woman doing? "Bart! Please! Just take the picture!" Finally, Bart takes the shot. We jump back in the car and drive around the corner and here's the show home, which is quite a fancy bungalow. We go inside and take a copy of the house plan and ramble around, and of course the realtor wanders over: "Are you folks looking for something in this neighbourhood?"

We explain that we live in Calgary, but I grew up in Saskatoon, more or less implying that, you never know, we might move back. He's looking at us, and you can see he's thinking, "Boy, you look familiar." The *StarPhoenix* has been really generous with its coverage of me, and probably he's seen a picture. Then, as we're leaving, the realtor is standing at the front door, and you can tell that he's trying to read what it says on the vehicle, which is parked at an angle. At this point, we're driving a jeep that has been loaned to us by a dealership in Drayton Valley, Alberta, and on the side it says, "Catriona Le May Doan, 1998 gold medallist."

So the realtor is squinting and saying, "Is that a company vehicle?"

And we say, "Yes. Yes, it is."

As we drive away, we see the realtor standing at the front window. Now, he can read the side of the jeep, and Bart says he's just figuring it out now. Bart laughs and wonders if maybe we should have said something. But I felt bad that we weren't there to look at houses, but to see what was happening on the street. I couldn't go in and say, "Hi, this is who I am and this is my street!" Even though I'm sure he would have understood. He might even have insisted, as Bart says,

on taking a photograph. Right! As if that's what I want – a shot of me in my Sunday-afternoon shorts on the wall of this fancy show home.

Even so, I have to say that the kids are the best. I visited a lot of elementary schools last spring, and when you haven't gone into the schools for a while, you forget how honest kids are. They want to hear your stories and look at your medals and just go, "Wow!" That's so refreshing. You get basic questions, funny questions, really honest questions. Questions like, what do you wear under your skinsuit? The answer, if you're reading this, is none of your business!

But it's refreshing to talk to the kids and realize that when you were their age, you would have asked those same questions. I like to make the kids understand that even if you're an Olympic athlete on television, you're still just a normal person. They think, "I could never go to the Games. I could never do this or that." And I like to stand in front of them and say, "Listen, I come from a town just like this one. And if I can do it, you can, too."

Even when I'm done skating, I would hope to remain a role model for kids. I would hope to keep that connection. After the Nagano Olympics, teachers and students at the Saskatoon French School, which I once attended, put together a wonderful scrapbook of clippings and letters, and that's something I still cherish. And I'm happy to report that I'm still receiving letters from children. Not long ago, a girl named Katie Wilson sent me one designed like a Canadian flag, coloured red on the outside and white in the middle, complete with a red maple leaf:

Dear Catriona Le May Doan:

Hi. I am Katie Wilson. I wrote some of my speech about you and I made it to the finals. You are my number one hero.

I found out that you live in Calgary. I have been there about seven or eight times. My aunt, Kathy Jennings, lives there, and my Dad has a job out in Exshaw.

I was sick during the week that you competed in Salt Lake City. But even though I was sick, there was just one moment that I forgot that I was. Actually, 37.45 seconds, to be exact. This was when my hero had passed the finish line with a gold medal finish.

I would like to be a speed skater just like you. So if you see Katie Wilson standing on the top step of the podium, think of it as another gold to your collection, because you are the main reason I got there. Thank you, Catriona, for helping me. I hope to see you in the year 2006.

Sincerely, Katie Wilson

Shall I give you one more example? Also after the Salt Lake City Olympics, Sarah O'Connor of New Brunswick sent me a letter in a little ring-binder notebook with a Christmas tree on the front. It's exactly the kind of notebook I would have sent when I was her age. The pages are all different colours, and that makes it much more exciting. Sarah wrote one or two lines on each page, so her letter reads like a poem:

Dear Catriona Le May Doan.
I am Sarah O'Connor.
I love you so much, I am your best fan.
I hope I am you some day. My favourite sport is speed skating.
I have been skating for four years.

I think you are so good at speed skating.

I hope I will be in the Olympics some day.

I am having a birthday on May 20th, 2002.

I will be ten years old, but my real birthday is May 18th.

I really would like you to come. I know you are busy, but please try to come. And I know more people want to see you, but I want you to come for my birthday party. And if you come we will have a skating party.

Please come because I am your biggest fan. Please, Catriona. I know you do not know me, but I am nice and so are my friends. You do not have to come, but I will not be happy if you do not come. If you will come I live in Canada, New Brunswick.

Sarah gives me her street address, her phone number and her e-mail address. She signs her letter, "Your best friend, Sarah O'Connor. I love you, Catriona."

I was unable to attend that birthday party. But I did respond to both Katie and Sarah, because letters don't come any better than those. Letters like those tell you that you have affected a child's life, and to me, that is so important. You work hard at accomplishing your goals, but at times you look up and wonder, "What's the point of all this?" Then you receive a letter from a Katie Wilson or a Sarah O'Connor, and you realize kids are watching you. You realize that for some kids, at least, you have become a role model. For me, that's the gold – receiving letters like those. That's the gold that keeps me going.